VENI VADI VICI

This work was brought to you by

The School of European Swordsmanship

www.swordschool.com

And the patrons of this work who donated through Indiegogo and directly.

ISBN 978-952-93-1686-1 (paperback)

ISBN 978-952-93-1687-8 (hardback)

ISBN 978-952-93-1688-5 (PDF)

ISBN 978-952-93-1689-2 (EPUB)

Book Design by Zebedee Design & Typesetting Services
(www.zebedeedesign.co.uk)

Printed by Lightning Source

VENI VADI VICI

A TRANSCRIPTION, TRANSLATION AND COMMENTARY
OF PHILIPPO VADI'S DE ARTE GLADIATORIA DIMICANDI

GUY WINDSOR

Six Arrows bundled in a Sheaf,
Symbol of the Cameron Clan,
Symbolise the many Strengths
Of this most exceptional Man.

Warrior on the open Sea,
Agent too, clandestinely,
Master of the Classic Field,
Standing fast with Spear and Shield,
Following the Martial Way,
Those that Fight, not those that Pray.

Above all these, he brings to Life
The Ancient Greeks, in Love and Strife,
Alive again upon the Page,
Revived to grace the Modern Age.

Kind Patron of this little Book,
Its Author hopes that he will look
Favourably on its feeble Charms,
And follow still the Art of Arms.

TABLE OF CONTENTS

INTRODUCTION

THIS BOOK BEGAN with a conversation at the Helsinki Knife Fair in January 2012, where I met the sword designer and smith Peter Johnsson for the first time. He pulled out his laptop and introduced me to his astonishing new theory that medieval swords were designed using the same sacred geometry as medieval architects used to build cathedrals.[1] The hair stood up on the back of my neck, and a whole lot of little pieces suddenly slotted into place. The first thing that came to mind was Vadi's insistence that swordsmanship was a science, not an art, and akin to music and geometry. He doesn't really expand on this idea much, just states it as an opinion. And then he goes on to define the size of the sword you should use. Vadi is the earliest author we know of to do so. So I dug out my copy of Porzio and Mele's 2003 translation and copied out the relevant passages (Chapters 2 and 3), and sent them off to Peter. As I did so, I became aware of some niggling errors in the translation, but let it go.

I work instinctively – I think about what I want to do, in very general terms, and set the goal to my subconscious (e.g. "open a school of swordsmanship"). I then get out of the way and do what I am moved to do. So within a few days of meeting Peter, I found myself obsessed

1 This theory has been published in The Wallace Collection's The Noble Art of the Sword, pp 142-149.

with geometry, and geometrical design, and started creating from scratch a full-scale model of my school's logo (a shield with various motifs on it, with a longsword and a rapier crossed behind it). I took as my base unit of measurement the longsword that would sit behind the shield. I had no idea what I was really doing until some of my students came up and asked me, and I patiently explained that I was hooked on Vadi, and to understand what he meant by geometry I had to get a grip on the principles of geometric design and proportion. So I was building a full-scale model of the logo. In other words, I was immersing myself in practical, straight-edge-and-compass, geometry for hours at a time, to get inside the head of a long-dead swordsman and gain insight into his treatise.

It wasn't long before I started transcribing and translating the book for myself, starting with the chapters on geometry and sword design. But then the project took on a momentum of its own and before I knew it I had about half the manuscript written out and rendered into English. This was taking up hours and hours of my working time, so I thought I'd better finish the job and see if I could persuade anyone to buy it.

I set up a campaign on Indiegogo to allow the prospective readership to make itself known and to act in the manner of arts patrons since time immemorial – to subsidize the artist. This went far better than I had any right to expect. The list of patrons is at the back of the book.

A MARTIAL FLOWERING

Discussing Philippo Vadi's work without mentioning Fiore dei Liberi would be like discussing sailing ships without mentioning the sea. There is no doubt that Vadi is building on Fiore's prior work, *Il Fior di Battaglia*. Some parts are lifted whole from one book to the other, some others are modified. But there is still a lot of original material here.

This does not mean that Vadi trained in a direct lineage from Fiore: it is likely that his training (assuming he is telling the truth and did have some) came from a related style, but he makes no mention of Fiore at all, anywhere. If he was a representative of the master's art, he would surely say so (as indeed the Liechtenauer descendants do in the

contemporary German treatises). It is perhaps more likely that he came upon a copy of Fiore's work and copied bits of it. Assuming he did, and assuming he only saw one copy, the question is which one?

Of the surviving Fiore manuscripts, we can discount the Morgan MS as it is missing the dagger material. The Florius MS (Bibliotheque Nationale Francaise) seems unlikely as it is seriously lacking in textual detail, though there are some interesting correlations in the sword plays. Only the Getty MS and the Pisani Dossi MS have all the material that Vadi borrows, and of these two, it seems more likely to me that the Getty MS is the source because the ordering of the material is strikingly similar. For instance, where Vadi shows defences against a backhand dagger strike, the plays follow the same order as in the Getty, which is different to the Pisani Dossi.

It is entirely possible that Vadi saw a version that is lost to modern scholars. Be that as it may, as part of the commentary on this translation I will note the equivalent play in the Getty, where possible.

The material that makes this book so much more than simply a rehash of Fiore is Vadi's explanation of the principles of swordsmanship, and his apparently original introduction of many new guards. I'll discuss them in detail in their chapter of the book, but this does support, at least in part, Vadi's repeated claim that he is representing a new way of fencing.

It was normal in this period for authors to appeal to authority wherever possible, so it seems strange that while Vadi acknowledges his teachers in general he does not name any, and makes no explicit reference at all to Fiore. One interesting theory regarding the creation of this book is that Vadi wrote it as a kind of job application to the court of Urbino, and borrowed much of his material from a copy of *Il Fior di Battaglia* that he may have found in Ferrara where he was apparently a medical student. There is no record of him ever being in Urbino in person, so the application was probably unsuccessful – and we know that Pietro Monte was employed there in the late 1400s. Perhaps the Duke had his own copy of Fiore and was unimpressed by such bare-faced plagiarism?

An interesting online history of Vadi's family can be found here:

http://www.achillemarozzo.it/articoli/vari/storiavadi.php, noting especially the bronze medallion forged in 1457 by Giovanni Boldu. On its reverse side it has a picture of Vadi holding a sword by handle and blade, with a sun by his right foot and a tower by his left, standing on a millwheel, just as depicted on Folio 15R. It is curious to note that the medallion was struck some 25 years before the earliest dating of the manuscript, suggesting that Vadi wrote it quite late in life, or that the man on the coin is not our author.

DATING THE TEXT

This book is traditionally dated from 1482-1487. It cannot be older because it is dedicated to Guidobalodo da Montefeltro as Duke of Urbino. Guido inherited the title in 1482. Had Guido's father still been alive, Vadi may well have still dedicated the book to Guido, but is unlikely to have promoted him in advance. It is possible that the book was written much earlier, and the dedication added later. This theory can only be confirmed or refuted by expert examination of the manuscript, which, as far as I know, has not yet been done. The latter date, 1487, comes from this book's presence in the Index of the Urbino library, which was completed in 1487. (From Bascetta, quoted in Mele, Porzio.) It is possible that the book was added to the index later, but I doubt it. The content of the book, covering the sword, spear, axe, and dagger, on foot, in and out of armour, places it firmly in the fifteenth century. By the turn of the 1500s, the art of fencing had changed significantly, with the longsword being largely abandoned in favour of a single-handed sword. The longsword as a sidearm was out of fashion before 1500; it grew into the mighty two-handed spadone, which is far too big to wear on the hip. Vadi's sword appears from his description and the illustrations to be significantly longer than the longsword we associate with knightly combat: surviving examples from the early 1400s tend to be no longer than would reach to the sternum: Vadi's reaches the armpit. This is a difference on most people of about three inches, which may not seem that much in real terms, but does quite dramatically alter the sensible use of the weapon, and the measure at which it is fought. Vadi's sword is perhaps

a developmental stage between Fiore's *spada a due mane* and the Bolognese *spadone*.

So, while the book was probably not written before 1482, it likewise would not have been written much after 1490, at least not without including a rant about the parlous state of affairs of modern fencing with their silly short swords etc., so in my opinion we can safely date it to between 1482 and 1487.

ABOUT THE TRANSCRIPTION

The book is handwritten, of course: the printing press was invented about 30 years before this book was written, and was not in widespread use yet. This presents a layer of difficulty in that while this book is written in a clear and probably professional hand, it uses inconsistent spelling, inconsistent word breaks, and all sorts of contractions. A p with a cross through the tail is "per"; nó (the accent on the o should be a squiggly line) is "non"; usually this is pretty straightforward to figure out from the context or from experience, but not always. Where there was doubt, Capelli's *Dizionario di Abbreviature Latini ed Italiani* was very useful. Word spacing was also challenging at times – especially where reading a set of letters as one word gave one meaning, and separating them out into two words gave another. The best course I found was to read the text out loud, as written. That usually resolved the issue, as one reading would make sense, and the others not. When reading the transcription, bear in mind that the letters U and V are interchangeable, and that the decorative capitals are drawn in later – and sometimes wrongly. The punctuation is also interesting: Vadi (or his scribe) is clearly using periods, commas and colons, but not as we would – for instance he puts a period at the end of every line of verse, regardless of whether it is the end of a phrase or just the end of the line. I have interpreted the punctuation accordingly, and included it in the transcription, but used modern conventions in the translation.

We must not forget that this book has been lying about for over 500 years. It is in remarkably good shape (when lived this long you have, look this good you will not), but there are some areas where a word is

obscured by damage or wear. Usually, it only affects one line, and as most of this book is written in rhyming couplets, knowing the rhyme allowed me to recreate the lost word with confidence.

In the transcription I have preserved the original spelling, punctuation and capitalisation, but expanded all the contractions.

ABOUT THE TRANSLATION

By an accident of education, I am reasonably familiar with the romance languages Spanish, French and Italian: I lived in Argentina from 1979-1980, and in Peru from 1986-1992. This gave me a tolerable fluency in Spanish. At my first boarding school I was force-fed Latin and French; at my second, French and Spanish, with a bit of Italian. While at University I took a year of Spanish, and in my final year took a course in "14th century poetry of pilgrimage", which included studying Dante in the original. I had no idea at this stage that my swordsmanship hobby would become a career, nor that the Latin, French, Spanish and Italian would form the basis of my choices of specialty within that career. As I see it, no professional in any discipline should rely on translations for their interpretations. Would you trust the opinion of a professor of Russian literature who could only read Chekov and Dostoyevsky through someone else's translation? So when choosing treatises to study, I naturally chose the ones that didn't require me to learn another whole new language. Fifteen years or so of wading through manuscripts like Fiore's and Vadi's has left me with the necessary skill-set to render their language into ours.

There is no translation without interpretation. Languages are not ciphers of each other, and a word-by-word translation usually produces nonsense. Words take their meaning from their context, and the true building block of a language is not the word, it's the phrase. There are words in every language that defy a simple translation, and phrases that have their equivalent only in a linguistically unrelated expression. It doesn't help that Vadi is not always the best or clearest of writers – take this paragraph for example:

Et per che alcuni animali in rationabili fano li loro artificii naturalmente te senza alcuna doctrina de l homo (Folio 2V) manca de artificio naturalmente si come el corpo de quello manca de arme debitamente lipressta la natura perlo mancamento de dire arme lemane et in loco de quello chel manca de artificii naturali li presta la virtu de intelecto et cogitatione e come se luii auesse auto alcuni artificii naturalmente non poria acquistare artificii perlo resto e per lo meglio alui adusare tutte learme e tutti li artificii pero non li fo prestato da dita natura ne arme ne artificio.

Which directly translated yields:

And because various irrational animals make things naturally, without any of man's theories, lacking natural devices, as the body of those that lack weapons doubtless nature gives them, to make up for the lack of the aforesaid weapons, hands. So to those that lack natural devices she gives the virtue of intelligence and thought and so those that have natural devices cannot acquire devices because the rest of them and the better to use all the weapons and the devices but not the ones given by the aforesaid nature no weapons nor devices.

Got that? Clear as a bell, isn't it. Parsing through it and banging my head on the table a few times to restore order gives me this:

And because the various animals, lacking reason, have natural gifts, without any of the knowledge of man (who lacks such natural bodily gifts). So instead of naturally occurring weapons, to make up for the lack of the aforesaid weapons, nature gives man hands. So to those that lack natural weapons she gives the virtue of intelligence and thought. Those that have natural weapons cannot acquire more weapons. So those that lack natural weaponry can better make use of all weapons, natural or otherwise.

Which can be redacted thus:

Animals lack reason, and cannot therefore use science or art, but have all sorts of naturally occurring tools and weapons. Men lack naturally

occurring tools and weaponry, but nature makes up for that by giving us hands and the intellect to use them intelligently. So it is the very lack of natural weapons that enables us to use all kinds of armament.

The translator's task, in my view, is to faithfully reproduce the original ideas in the new language; but not to make a good writer out of a bad one. I have stayed pretty close to the original, and have saved the rewriting and explanation for the commentary sections. In my choices I have been guided largely by the results of a poll I ran on this book's facebook page (oh for the days when the only pages you had to concern yourself with were the ones in the book!) and have kept it as literal as clarity allows.

Some individual words caused a lot of trouble – at times hunting down a single word would take as long as translating the entire previous page, or longer. My process was as follows: first, I looked it up on WordRef (http://www.wordreference.com). If that didn't help, I tried some alternate spellings, which sometimes produced hilariously inappropriate results. Failing that, I turned to the Vocabolario della Crusca (http://vocabolario.sns.it/html/index.html), with the original and alternate spellings. If the Vocabolario has it, we're home, as it gives the definition in Italian, and usually in Latin too. If the Italian definition didn't help me much, I went to Perseus (http://www.perseus.tufts.edu/hopper/) and figured out the Latin. Then I brought these results back and saw if they made sense in the context. At times I also used Florio's dictionary of 1611 (http://www.pbm.com/~lindahl/florio/).

There are particular words that Vadi uses for which the one-word English translation, while necessary, sorely misses the depth and resonance of the original.

Ragion

This means "reason", "type", even "system", and it crops up in several contexts. "Ragion di meza spada" as a chapter heading indicates that this is a laying out of the rationale behind the actions done at "meza spada". Vadi is insistent that his art is scientific, in that it is logical, structured, literally a product of reason, the highest capacity of Man,

the aspect that separates us from the animals. The function of reason is to order creation into types of things, and draw parallels and connections between them. Ragion can also simply mean type, as in "there are five types of thrust" – it is the capacity of reason that allows us to divide and order things.

Meza spada

This is literally "half-sword", and refers to the crossing made at the middle of the blades. Later thrust-oriented systems, such as rapier and smallsword, tend to emphasise leverage when parrying, and so try to aim the point of contact such that the part of your blade closest to the hilt meets the part of his closest to the point. In contrast all medieval sword systems I have encountered aim to parry middle to middle; this keeps your fingers safe, and allows you to beat the sword aside rather than simply push it out of line or block it. If the parry fails to beat the sword wide there is a moment at which the swords are crossed around the middle of the blades. This is what Vadi is referring to when he uses the term crossed at the "meza spada", half-sword.

Tempo

Tempo is literally "time", but also rhythm, or the length of an action. I have used whichever meaning of tempo fits the context best as I see it, but you should be aware that an entire book could be written on this one concept alone. At times, I have left it untranslated, as it is being used in a fencing-specific way that has become part of anglophone historical swordsmanship usage. Such as the next entry: mezo tempo:

Mezo tempo

This is literally "half time", but refers to the use of blows that stop in the middle of the target, instead of travelling through to the other side. Tempo in this instance means "completed movement" or something similar. So the "half time" is the use of "half blows".

Some terms I have left untranslated, as they are, or should be, part of any historical fencer's vocabulary:

Fendente
This is a downwards blow, forehand (mandritto, dirito, dritto etc.) or backhand (roverso, riverso, rovescio etc.). Generally, if dritto or roverso is used on its own it is a fendente.

Volante
This usage is as far as I know unique to Vadi, and means literally "flying". He uses it to mean a horizontal blow.

Rota
Again unique to Vadi, this is literally "turn", and is a rising blow, usually with the false edge, and I think he means it to be used repeatedly in a figure-eight, hence "turning".

ORGANISATION OF THIS BOOK
I have tried to organise this book to make it as user-friendly as possible to people interested in recreating Vadi's art. Readers of a more academic or theoretical bent may find this unorthodox, but then they are not the target readership. The most obvious omissions from the book are glorious full-colour reproductions of Vadi's plates. This is because they are freely available, with and without my translation attached. I have instead used small black and white reproductions as aides-memoire.

I have appended a gloss at the beginning of each of Vadi's introduction and theory chapters , so you can quickly scan the contents of the chapter, followed by the translation and transcription side by side. The gloss also contains my commentary.

When we get to the illustrated plays and segno pages I kept the material in the original order. Commentary regarding a section as a whole is at the beginning of that section, and commentary on the plays themselves are attached to each play.

I am making the assumption that the reader is familiar with Fiore dei

Liberi's *Il Fior di Battaglia*. If that is not the case I strongly recommend buying Tom Leoni's translation, Bob Charrette's *Armizare* and my *Mastering the Art of Arms* vols 1 and 2, to provide the necessary background for studying Vadi. All of these can be had from www.freelanceacademypress. com. In many cases my commentary on a specific Vadi play just points out which of Fiore's plays Vadi is copying, in the expectation that the reader will know where to look, or simply recall the play from memory.

THE DEDICATION

THE FIRST AND most obvious thing to notice about this dedication is that Vadi's Latin is execrable. He is clearly trying to praise Guido, Duke of Urbino, and place his work into a high-flung classical context. I doubt Guido was terribly impressed. This particular Duke of Urbino not only gathered about him one of the finest courts of Renaissance Italy, seat of learning culture and power, but also, having lost Urbino to Cesare Borgia in 1502, managed to wrest it back again in 1503. Not many men got anything back once a Borgia had stolen it. Guido was born in 1472, succeeded his father Federico as Duke in 1482 (which gives us the earliest date of this manuscript), and despite ill-health was a successful condottiero. Baldassare Castiglione's famous book, The Courtier, published in Venice in 1528, was based on his experiences at Guido's court.

Folio 1R Folio 1R

AD ILLUSTRISSIMUS PRINCIPEM To my most illustrious Prince
MEUM GVIDVM FERETRANVM Guido di Montefeltro
DVCEM VRBINATEM Duke of Urbino

Hvnc tibi do princeps dignissime guide libellum

I offer this little book to you, great Prince,

Cvi pariter mentem devoveoque meam

To which Muse my mind is devoted to,

Qvom musis studium dederis lege ludicra martis

When giving up song to study the law of the principal

Principibus muse: marque savere solest

martial games,

Hvnc te precipue phebus: museque decorant

Mars accustomed to kiss especially Phoebus (Apollo):

Mox etiam mauors: atque minnerva colent.

The muse next decorates Mars, and worships Minerva.

PHILIPI VADI SERVI LIBER DE ARTE GLADIATORIA DI

Philipo Vadi offers this book on the art of gladiatorial combat to the illustrious

MICANDI AD ILVSTRISSIMVM PRINCIPEM GVIDEM FERE TRANVM DVCEM VRBINI.

Prince Guido di Montefeltro Duke of Urbino.

Vadi's Introduction

THE INTRODUCTION TO the book is written in prose, in contrast to the rest, which is in verse. Vadi's prose is fairly dense and convoluted, especially compared to the clarity and ease of his verse. The writing here is repetitious, and needlessly complicated. But it sets out the target audience (the nobility), establishes Vadi's authority, and argues that the Art of Arms is an excellent and necessary accomplishment. In essence he is persuading us to train in it. The introduction is separated into two parts, indicated by an illustrated capital at the beginning of part two. He makes nine main points, three in part one, six in part two. They are:

Part One

1. This art is very useful in battles, wars, riots and other combat scenarios. Men trained in it find it a great help. So, it has been suggested that I put together this little book, to expand on the art, and prevent it falling into disuse. I have included illustrations and various exemplar techniques so that anyone who is familiar with the contents can apply them in assaults of arms, and defend himself intelligently.
2. Only the nobility are fit to use this art. Anyone who is not of the proper class must not be allowed to attempt it.
3. Everything in this book has been tried and tested, so there are no errors.

Part Two

1. Man has reason and intelligence which makes up for a lack of natural weapons. This places him above the animals. In the same way, a more intelligent man can overcome a less intelligent one, even if the latter is bigger and stronger.

2. It is also possible for one man to overcome many. This book shows not only attack and defence, but also disarms. And especially how a smaller weaker man can defeat a bigger, stronger one.

3. Vadi has travelled to many places, trained under many masters from a young age, has worked extremely hard, and is now a highly competent person to write this book.

4. The book covers axe, spear, sword and dagger. Everything in it has been tested. It contains a rational, scientific system of combat with illustrated examples, so people new to the art can learn it.

5. You need only be bold and clever to overcome anyone.

6. If the reader is well versed in the art, they may edit the book as they please.

INTRODUCTION, PART ONE

Folio 1R (continued)

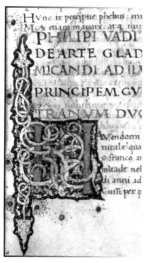

*Havendomi masso per apperito naturale quale producea
fuori emio franco animo alieno da ogni uiltade nelli mei
primi et floridi anni ad acti et cose bellicose cussi per processo
di tempo cre (Folio 1V: in middle of a word break: cresendo)
sendo in forze et insapere mi mosse per industria ad volere
inparare piu arte et modi de igiegno de dicti acti et cose
bellicose. Come e guichare di spada de lanza di daga et
azza. De lequal cose mediante lo aduito de summo idio
neo aquistato assai bomna notitia e questo por pratica
experientia et doctrina de molti maestri de varii et diversi
paesi amaestrati et docti in perfectione in tale arte. Et per
non minuire anzi volendo acrescere tal doctrina acio che per
mia negligentia epsa non perisca per che da epsa non procede
pocho alturio ne bataglie guerre rixe et altri tumulti bellicosi:
I mmo dona agliomini instruti et periti in tale materia uno prestantissimo e singulare
subsidio: Ho proposto et statuido nellamente mia de compillare uno libretto concernente
cosse: Lequalle sono piu oltra e piu prolixe de tale arte: depingendo in quello varie figure
e ponendoli exempli diverso per li quali qualunqua homo instructo in tal materia possa
usare nel fo asaltare et nel so diffendere astucie calidita et avisi di pui ragione et manere.*

Having been drawn to warlike acts and things by my earnest spirit, devoid of all cowardice, since my first thriving years, as time progressed I grew in strength and knowledge I went, through hard work, to learn something of the art, its style and skills, regarding the aforementioned warlike acts and things. Such as how to play with the sword, lance, dagger and axe. Of these things, through the guidance of God I acquired some good advice and this through the practical experience and theory of many teachers from various different countries, all complete masters and perfectly knowledgeable in this art.

And not to diminish but instead to increase this doctrine so that it will not perish from my negligence, because from it comes no small help in battles, wars, riots and other warlike tumults: instead it gives all men trained and instructed in this material immediate and unique help: it has been suggested and required that I compile a booklet concerning these things by people I have surpassed in the art, and am more long winded than: adding to this various figures and placing various examples so that any man versed in this material can use if for assaults at arms, and can defend himself intelligently and be advised of all the types and styles.

Adunque ciascuno di generoso animo vedera questa mia opereta amia epsa si come uno gioello et texauro et recordansello nelo intimo core acio che mai per modo alcuno tale industria arte e dotrina non perue (Folio 2R Page break mid word: peruenga) ga ale mane de homini rusticali e di vile conditione. Perche el cielo nona generato tali homini in docti rozi et fuori de ogni ingiegno et industria et oino alieni dalal agilita del copro ma piu tosto sono stati generati asimilitudine de animali in ragioneuoli aportare carichi et fare opere vile erusticale. Eper che debitamente ioui dico loro essere per ogni modo alieni datal scientia et perlopposito al mio parere ciascuno di porspicace ingiegno el ligiactro de le menbra sue come sono cortegiani scolari: baroni:principi: Duchi et Re debeno essere invitati acquesta nobile scientia secondo el principio de la Instituta quale parla e dice cosi. El non bixogna solo la maesta inperiale essere honorata di arme ma ancora e necesario epsa sia armata de le sacre legge.

So that everyone of a generous spirit will see this, my little work, as a jewel and a treasure, recording it in his inner heart, so in this way this useful art and doctrine will not fall into the hands of uncouth men and those of low-born condition.

Because heaven has not made these men in earthly flesh and beyond all cleverness and hard work and bereft of bodily agility, but instead they were made without reason, like animals, just to carry heavy loads and do base and rustic works. And so for this reason I tell you that they are in every way alien to this science, and it appears to me that the opposite stands for everyone of perspicacious intelligence and lively limbs such as

are courtiers, scholars, barons, princes, Dukes and Kings, who should be invited to this noble science according to the principle of the Instituta which states: not only should Imperial Majesty be honoured in Arms, but also armed with sacred laws.

Ne sia alcuno quale creda che in questo mio volume sia posta cosa falsa o in velupara de alcuno errore: perche rollendo erececando uia le cosse dubiose solo li metero cose uedere e prouare da me: Comenzando adunque ad exprimere la intentione nostra. Con la diuro et gratia de lo omniptente dio del qualle el nome sia benedetto in eterno.

Nobody should think that there is anything false or any kind of error in my book, because I have left out anything doubtful, and included only things that I have seen and tested. Let us begin then to explain our intention, with the aid and grace of the omnipotent God whose name will be blessed forever.

INTRODUCTION, PART TWO
(New capital letter, indicating new section)

Et per che alcuni animali in rationabili fano li loro artificii naturalmente te senza alcuna doctrina de l homo (Folio 2V) manca de artificio naturalmente si come el corpo de quello manca de arme debitamente lipressta la natura perlo mancamento de dire arme lemane et in loco de quello chel manca de artificii naturali li presta la virtu de intelecto et cogitatione e come se luii auesse auto alcuni artificii naturalmente non poria acquistare artificii perlo resto e per lo meglio alui adusare tutte learme e tutti li artificii pero non li fo prestato da dita natura ne arme ne artificio. Have adoncha bixogno tra glialtri animali lo intellecto e ragione nelequalecosse fiorisce arte et ingiegni de quali due cosse non solo auanza esupa tutti glianimali: Ma ciascuno homo docto et adoctato de bono ingiegno auanza e supedita qualunqua sia piu robusto di lui epiu pieno di forze.

And because the various animals, lacking reason, have natural gifts, without any of the knowledge of man (who lacks such natural bodily gifts). So

instead of naturally occurring weapons, to make up for the lack of the aforesaid weapons, nature gives man hands. So to those that lack natural weapons she gives the virtue of intelligence and thought. So those that have natural weapons cannot acquire more weapons. So those that lack natural weaponry can better make use of all weapons, natural or otherwise. Having then need above all other animals for intelligence and reason, these things flourish, art and intelligence, and not only these two things raise us above the other animals.

But every trained and clever man of good intelligence overtakes and surpasses any other that is tougher than him, and more full of force.

Iusta illud preclare dictum. Ingenium supare vires: Et quod maius est et quasi in credibile: sapiens dominabitur astris: Nasce da dito ingiegno et da altri epenetrative cogitatione una arte de uincere superare et debbetare qualunque vol conbatere e contrastare.

Just to expand on my previous point. Cleverness overcomes strength. And what is greater still and almost incredible: sapiens dominabitur astris (Note: this means "the wise man is ruled by the stars", but it is almost certain that Vadi, like many others before and since, misread it to mean "the sage rules the stars"). An art that conquers all, and dominates anyone who would fight you or stand against you, is born from the aforesaid cleverness and other piercing thinking.

Et non solo adviene che uno homo uinca laltro ma ancora nasce modo et posibilita che uno solo superi piu persone e non se mostra solo el modo et documento de assaltare lo adversario et repararsi et defendersi da lui ma etiam se insegna adui (Folio 3R) si de togliere larma sue di mano:

And not just one man against another, but also a method and the possibility is born for one man to overcome many people. And not only is shown the way and theory of combating the adversary, and to defend yourself against him, but also is taught advice on how to take the weapon from his hand.

Perli quali documenti spese siate uno de poche forze et picolo sottomete prosterne et
sbate uno grande robusto e valoroso e cusi aduiene che anche uno humile auanza el
superbo et uno disarmato lo armato. Et molte volte accade che uno apie di vinci et
sconsingie uno da cavallo.

In these texts there will also be a few words on how a small person of
little strength can overcome and throw down a big tough and brave man,
and so you will see how the humble can overtake the great and the
unarmed the armed. And many times it happens that someone on foot
defeats and conquers someone on horseback.

Ma perche el seria cossa molto inconveniente che cosi nobile doctrina per negligentia
perise e venise meno. Io philippo di vadi da pisa hauendo ateso atale arte infino ali
mei primi et floridi anni hauendo cercato et praticato piu et diversi paesi et terre castelle
e citade per racogliere amaestramenti et exempli da piu maestri perfecti nellarte. Perla
dio gratia hauendomi acquistato et conseguito una particella assai suffici ente ho de
liberato co conponere questo mio libreto nel quale uesiponera et dimostrara almeno la
noticia di quatro manere darme cie lanza, spada, daga, e, aza.

But because this is a serious matter it would be very inconvenient if
this noble doctrine perished and diminished through negligence, I,
Philippo di Vadi from Pisa, having studied this art since my first
flourishing years having travelled to and practiced in many different
countries, lands, castles and cities to collect the teachings and examples
of many perfect masters of the art. By the grace of God having acquired
and followed a sufficient quantity of the art I have been free to compose
this, my little book, in which I have organised and shown at least the
main points of four types of weapon: the lance, sword, dagger and
axe.

Et in epso libro permi si descrivira regole modi et atti de talle arte metendo li exempli
con varie figure acio che ciascheduno nouo nelarte comprehenda et cognosca limodi de
assaltare et per lequalle astutie et calidita lui expella et rebuti da se le contrarie et
inimici col pi ponendo solo nel dicto libro quella doctrina (Folio 3V) vera et bona la

qualle io con gradissimi affanni et fatiche et vigilie ho inparato da piu perfectisimi
maistri metandoli ancho cosse per mi atrovate et spesso provate.

And in this book written by me I describe a properly organised theory
and practice of this art, with examples illustrated with various figures, so
anyone new to the art can understand and know how to fight, and by
which tricks and vigour he expels, beats aside those of opponents and
enemies. I have only included in the aforesaid book the good and true
doctrine, which I have received from the most perfect masters, with great
pains, and efforts, and vigils. And I have also included things that I have
discovered and often tested.

Ricordando et amonendo ogniuno non prosuma temerariamente ne habia ardire de in
terme terse intale arte et scientia se lui non ne magnanimo epien de ardire: Perche
qualuncha homo grosso dinzegno pusilanimo et ville debbe essere caciato et refudato da
tanta nobilita et gientileza: Perche solo acquesta doctrina se debeno inuitare sacomai
Homini darme scolari baroni Signori Duchi Principi et Re di terre de li qualli ad
alcuni de loro apertene agovernare la republica: et adalcuni de loro apertene deffendere
pupili et vedoe: Et tute due sono opere diuine et pie

Reminding and admonishing all, in plain words, to not dare attempt this
art and science unless they are bold, generous and full of courage. Because
any coarse, low-born, pusillanimous man must be chased away and blocked
from such nobility and refinement. Because to this doctrine should only
be invited such men as: men at arms, scholars, barons, lords, dukes, princes
and kings of the land and any of those that govern the republic, and to
any of these who defend widows and orphans (both of these are pious
and divine works).

Et se questa mia opereta porvenisse amane de alcuno docto nella arte et paresseli che
in epsa sosse alcuna cossa superflua oma? che vole piazali de resecare minuire et
acrescere quello li parera perche infino damo io mi sottopono
ASUA CORRECTIONE ET CENSURA.

And if this my little work finds its way into the hands of anyone versed in the art and appears to him to have any superfluous or wrong, please adjust, reduce or add to it as he pleases. Because in the end I place myself under his correction and censure.

CHAPTER ONE

MUSIC AND GEOMETRY

THIS CHAPTER INTRODUCES the idea that swordsmanship is to be thought of as a science, in other words a matter of specific knowledge, rather than an art. These terms have changed over time, as his statement that Music is a science clearly shows. Education at this time was largely divided into two groups of subjects. The trivium are the three contingent or humane subjects: Grammar, Rhetoric and Logic. The quadrivium comprises the sciences: arithmetic, geometry, music and astronomy. These can be thought of (and were in Vadi's time) as the study of numbers and their relation to each other (arithmetic); numbers in relation to space (geometry), numbers in relation to time (music) and numbers in relation to space and time together (astronomy). Geometry, for instance, literally means "earth-measuring", and above all is the study of proportion. The mathematics of music have been endlessly researched by better scholars than I; suffice to note that in this period, long before pitch could be objectively measured, the mathematical aspect of music was primarily its rhythm. It is a truism to say that fencing is one half distance, the other half time: tempo (time and rhythm) and distance are the key objective measures. As Vadi himself notes on p15R

Io sono sexto che fo partimenti	I am callipers, that divide into parts,
O scrimitore ascolta mia ragione	O fencer heed my reason,
Cusi misura et tempo simelmente	Thus measure the tempo similarly.

In other words, measure distance (with the figurative dividers or compass) and time (tempo) together. In practice, this refers to the way that fencing time works. Any action takes time, and the longer the action, the more time it takes. So, if you need more time, you take distance; if you need more distance, it will take time. "Tempo" is also rhythm, and a more specific connection between Music and Geometry is hard to imagine. Fencing is the perfect correlation between actions in space and actions in time.

This is supported nicely by Aristotle's theory of time as presented in his Physics books 7 and 8, as referred to by Angelo Viggiani in his Lo Schermo (1575; written in about 1552). Lo Schermo is in many ways the Rosetta stone for early Italian fencing theory. In it, Viggiani determines that the guards are the beginning and ends of blows. The point is that a body begins at rest; then is in motion and then at rest. The motion of the body determines its time. The tempi of rest, and tempi of movement, are measured relative to each other. Or as he puts it:

All right, it suffices that each motion that is single and continuous lies between the preceding and subsequent rest; look, then, Conte: before you throw a mandritto, a rovescio, or a punta, you are in some guard; having finished the blow, you find yourself in another guard; that motion of throwing the blow is a tempo, because that blow is a continuous motion; thus the tempo that it accompanies is a single tempo; when you rest in guard, having finished that motion, you find yourself once again at rest; it is therefore atempo, a motion, which instead of calling a "motion", we call a "tempo", because the one [64R] does not abandon the other; and the guard is the rest and the repose in some place and form. In conclusion it is as much to say "tempo" and "guard", as it is to say "motion" and "rest". Whereby it is necessarily so, that as between two motions there is always a rest, and between two rests there is interposed a motion, apparently between two thrown blows, or two tempos, or two motions, is found a guard. And between two guards, or rests (as you wish to say) are interposed some blow and tempo.

(Trans. Jherek Swanger.)

| 34 |

Capoferro (Gran Simulacro dell'arte e dell'use della scherma, 1610) is also useful here:

> In fencing, the word tempo means…that proper interval of motion or stillness I require to carry out a specific action; in this case, it does not matter if the time is long or short, the only concern being that I carry out the action. In the art of fencing, I require a specific and appropriate interval of time and motion to arrive into measure; it does not matter whether I arrive sooner or later—what matters is that I arrive where I intended to arrive. …Next, the word tempo is taken to mean speed in relation to the length or brevity of motion or stillness. As in the art of fencing there are three measures (or distances) from which to strike, so there are three distinct tempi. In this case, it is not enough that I reach a certain end; what also matters is that I reach it with the required speed and promptness…Tempo is nothing but the measurement of stillness and motion.
>
> <div align="right">From Chapter V, trans. Tom Leoni.</div>

This chapter lays out the theoretical underpinning of the system as Vadi sees it. It is a welcome advance on the earlier practice of simply providing exemplar plays and leaving the reader to deduce the principles behind them.

Folio 3v (continued)	Folio 3v (continued)
Capitulo Primo Incipit	Chapter I begins.

Se alcun volesse intendere a sapere.	If you wish to truly know
Serlo scrimir e arte over sienza.	If fencing is an art or science
Io dico che tu noti el mio parete.	Hark my words, I say.
Considera bene questa mia sentenza.	Ponder this, my conclusion:
Che le scienza vera e no e arte.	It is a true science and not an art
E mostrallo con breve eloquenza.	As my brief eloquence shall show.

Folio 4R Folio 4R

La Geometria che divide e parte.
Per infiniti numeri e misure.
Che inpi di scientia le sue carte.

Geometry divides and separates
By infinite numbers and measures,
And fills her papers with science.

La spada e sotto posta a le sue cure.
Convien che si mesuri i colpi ei passi.
Acio che la scientia ta secure.

The sword is placed in her care,
So measure blows and steps together
So Science keeps you safe.

Da Geometria lo scrimir se nasce.
E sotto poste alei e non na fine.
E luno a laltro infinito fasse.

From Geometry fencing is born,
And under her it has no end;
And both of them are infinite.

E se tu notarai le me doctrine.
Tu saperai responder con rasone.

And if you heed my doctrines,
You'll know how to answer with
 reason

E caverai la roxa de le spine.

And pluck the rose from the thorns.

La musica ladorna esa sugetto.
Chel canto el sono senframette in larte.
Per farlo di scientia piu perfecto.

Music adorns this subject,
Song and sound enshrine the art,
To make it more perfect through
 science.

Per farte chiare ancor tua opinione.
Per aguciarre meglio linteletto.
Acio che tu respondi a le persone.

To make your opinion clearer,
And to sharpen your intellect,
So you may be able to answer to
 everyone:

La geometria e musica conparte.
Le loro virtu scientifiche in la spada.
Per adornare el gran lume de Marte.

So Geometry and Music combine
Their scientific virtues in the sword,
To adorn the great light of Mars.

Or vidi sel mio dir ponto tagrada.
E la rasone chio talego inscripto.
Et tiella nel cervello che no te cada.

Now if you like what I have said,
And the explanations I have written
Keep them in mind, so you will not
 fall.

Che tu respondi el ver come io to dicco.	So answer true as have told you,
Che in lo scrimir non se trova fine.	In fencing you will find no end,
Cogne riverso trova il suo dritto.	as every backhand finds its fore,

Folio 4V

Contrario per contrario senza fine.	Counter by counter without end.

CHAPTER THREE

PRINCIPLES OF THE SWORD

THIS IS A long, involved and detailed discussion of several aspects of swordsmanship. The title alone invites a lengthy discussion. Ragion de Spada means type, reason, principle or system of the sword. Basically, the ordering into a rational construct of the essence of the sword. Principles of the sword, or principles of swordsmanship, are close to conveying the meaning. In many ways this is the most important chapter of all, as it gives the most general insights. I'll summarise them here, in the order in which they occur in the text:

1. The sword is a cross and a royal weapon. It is to be used with martial vigour.
2. The art of the sword lies in the crossing of the blades.
3. Use cuts or thrusts as necessary
4. Blows are divided into forehand and backhand.
5. Use the true edge for forehand blows, and backhand fendente blows. Use the false edge for backhand rising and horizontal blows.
6. Stand side-on to your opponent, and stay side on when passing forwards or back.
7. Hunt his face with your sword.
8. Keep your eye on his weapon.
9. Seize the measure and tempo together.

10. If he strikes, parry.

11. Your parry should not be too big

12. When joined at the half-sword (i.e. Middle to middle) leave the wide play and constrain and confront him.

13. If you feel weak, you don't want to end up in zogho stretto, so parry from the left, passing out of the way, and strike.

14. If you feel cunning, then go to the zogho stretto.

15. Cover (parry) and immediately strike.

16. Exchange the thrust if you can. (The instructions are very similar to Fiore's at the 9th play of the 2nd master of zogho largo.)

17. Or break it to the ground if you can't (as in Fiore's 11th and 12th plays of the second master of zogho largo).

18. Move with (not after) your opponent.

19. Wisdom, strength and boldness are needed. If you lack them, train more!

20. Don't play nice. It will get you killed.

21. Use trickery.

22. Don't be quarrelsome.

23. Be just.

24. Do not offend without reason.

25. Honour your teacher – money does not repay what you owe him.

26. Be good at teaching and learning.

27. This art gives you something in common with kings and princes.

28. This art will make you rich. (Good luck with that! GW)

29. This art maintains public order.

30. If you are exhausted, don't worry, you will get better.

31. This is a new art.

32. This art has been kept secret but is now released.

For those of us most concerned with recreating the Art in practice, the critical parts of this chapter are points one to 21. It is especially interesting to note that the art revolves around the crossing of the swords, as it does in Fiore, who defines several different crossings. They are (from the Getty, Pisani-Dossi and Morgan, all forehand v. forehand)

the crossing of the swords at the tips in zogho largo, at the middles in zogho largo, and at the middles in zogho stretto. In the Morgan he also refers to the crossing of the swords *a tuta spada*, in which the swords cross near the hilts. And in the Pisani Dossi he shows an additional crossing of the swords in zogho stretto backhand v. backhand. Vadi concerns himself only with the middle-to-middle crossing, and from the context it's clear that it is equivalent to the *zogho stretto* crossing that Fiore shows.

If we look at the pattern of the longsword plays in the Getty MS, we first see 11 coming from a backhand parry, then 20 *zogho largo* plays coming from a forehand parry, then 23 *zogho stretto* plays of which all but two are from a forehand v. forehand crossing. Then we see a backhand parry from any left-side guard again, against any kind of blow. The message is clear: to keep things simple, parry from the left. If you parry from the right, the potential complexity of the play is vastly increased. Vadi says the same here: you can avoid all this *meza spada* complexity (he later illustrates 25 plays all of which can be done from the *meza spada* crossing) by simply parrying from the left instead.

I will leave the detailed commentary on the other points for later, as Vadi himself will expand on them in the following chapters.

Folio 4V (continued)	Folio 4V (continued)
Capitolo III	Chapter III
Ragion de Spada	Principles of the sword

Piglia la spada in mano virilmente	Grasp the sword manfully,
Perche le croce est e unarme reale	Because it is a cross, and a royal weapon,
Insieme acorda lanimo valente	Together with a bold spirit.
Si tu averai nel cervel tuo fale	If you have a sharp mind,

 Folio 5R

El te bixogna qui considerare
Qual via fal di sopra da falir tal scale.

You must consider here,
The way to climb these stairs.

Larte de spada et solo in incrociare

The art of the sword is just in
 crossing,

Partir la punta et I colpi ala contexa
Per far la guerra achi vol contrastare.

Suiting thrust or cut to their context,
To make war on he who stands
 against you.

Da una parte si fano difexa
I colpi diritte da un lato vada
I riversi da laltro faccia offexa

On one side you make defence
The forehand blows go one one side,
The backhands attack from the other.

El taglio ritto nel suo ritto cada

The true edge falls on the forehand
 side,

Et fa che note bem questa ragione.
El riverso col falso piglia strada.

And note well this truth
The backhand and false edge go
 together.

Et fa che segui poii comel dir pone
Metteti in posta con la spada in mano

And follow then as the saying goes,
Place yourself in guard with the
 sword in hand,

Stu passi otorni remane in galone.

If you pass forwards or back remain
 side-on.

Perche non sia el tuo guicare invano
Da quella parte che volto hai la faccia
Da quella entra e non te para strano.

So that you will not play in vain,
Face the side to which you turn,
And enter there, if this is not strange.

Mettendo la tua spada alora in caccia
Verso el compagno con la punta alvolto

Letting your sword go hunting
Against the companion with your
 point in his face,

E deferiri subito te spaccia.

Ready to strike immediately.

Esser ti bixogna acorto molto
Con lochio alarma che te po offendere

You must be very shrewd,
Keep an eye on the weapon that can
 strike you,

Pigliando el tempo el misurar racolto.	Grabbing the tempo and measure together.
Fa chel cor sacorde nel defendere	Make your heart agree with your defence
I piedi e braccia com bona mesura	The feet and the arm with good measure,
Se honor vorai altutto prendere.	That you may take all the honour.
Et nota bene et intendi mia scriptura	And note well and understand my text
Che sel compagno tra con la sua spada	That if the companion strikes with his sword,

Folio 5V	*Folio 5V*

E con la tua ad incrociar procura.	With yours acquire the crossing.
Guarda non vadi pero for de strada	Your guard should not go out of the way,
Va con coverta e con la punta aluixo	Go with the cover and with the point raised
Martelando ala testa i colpi vada.	The blows hammer the head.
Giocha de croce e non seraii conquixo	Play of the cross and you will not be conquered,
Sel compagno in crocia largo et tu ponta	If the companion crosses wide and you thrust,
Volendo tu dalvii non star diuxo	You want to not be divided from him.
Quando la sua a meza spada egiota	When you are joined with him at the half-sword,
Stregnire a lui che la ragione el vole	Constrain him as reason desires,
Elassa el giocho largho et qui ta fronta.	And leave the wide play and confront him.
Ancora spesse volte achader sole	Also sometimes it is so,
Che lhom non sente aver bona forteza	That a man doesn't feel himself very strong,
On qui bixogna ingiegno e non parole.	Then he needs cunning, not words.

Passa for de strada con destreza	Pass out of the way with skill,
Con la coverta del bon man reverso	With the cover of the good backhand,
Rendopiando el derito con prestezza	Redoubling swiftly with a forehand.
Si tu non senti aver lingiegno perso	If you don't feel your cunning has been lost
Lassa al largo et tienti al guicar stretto	Leave the wide and find the constrained play
Farai ala fortezza mutar verso.	Make strength change sides.
Et fa de note et intende questo detto	And take note of and understand this saying,
Che quando incroce incrociarai per forza	That when crossing, cross with strength,
Per che smorza de spada il suo diffetto.	To lessen the threat from his sword.
Sapii che ingiegno ogni possanza sforza	Know that cleverness always overcomes strength,
Fata la coverta et presto alo ferire	Make the cover and immediately strike,
Allargo et stretto abaterai la forza.	In wide and constrained you'll beat down strength.
Et se la punta li voi far sentire	And if you want to make him feel your point,
Va for de strada per traverso passo	Go out of the way with a pass across
Fagli nel peto tua ponta sentire.	Make him feel your point in his chest.
Con la punta alta et col tuo pomo basso	With the point high and the pommel low
Ei bracci infora Con bona coverta	And the arms inside with a good cover,
Passa dallato stanco de bon passo.	Pass to the left side with a good pace.
Et se la punta trova la via aperta	Control him and grasp the grip of his sword,
Passando pur di fora non temere	If this cannot be done well,
Che in ogni modo li darai loferta.	Crushing his sword does the duty.

Stregnilo et piglia alor suo mantenere
Se questo vede non posser bem fare,
Pestulando sua spada fa el dovere.

And the point will find an open way,
Passing to the outside do not fear,
In every way you will make your offer.

Fa che tacordi sempre nel passare
Col tuo nimico opure quando tal trove

Always match your passes
With the enemy's, and when you find him

E questo chio ti dico non lassare

This I say – do not let go!

Come tu vedi che la spada el move
Opur passare overamente tragga
Over tu torna o dosso fa chel trovi.

When you see that the sword moves,
Or if he steps, or strikes,
Or you pass back, or make him find a bump.

Sapere, fortezza et ardimento agga
Colui che vole in arme avere honore

Wisdom, strength and boldness act
With him who desires honour in arms,

Se questo manca a sercitar si stagga.

Lacking these, he must exercise more.

El ti bixogna havere ardito il core
Se lomo grande te paresse forte
Lingiegno adopra che te da favore

You must have a bold heart,
If a big man appears strong
Using cunning will give you favour.

Guarda bem certo como da la morte
Chel tuo giucar non sia per cortesia
Con altri che vergogna tito porte

Be as certain as death
That your play is not courteous,
When the other tries to shame you

Et nota ben questa sententia mia
Tu conosci tuo cor non del compagno

And note well this text of mine,
You know your heart, not the companion's

Folio 6V

Folio 6V

Non voler mai usar tal fantaxia
Fa che tu sie de malitia magno
Situ voi aver seguito in tal arte
Arai bom fruto de cotal guadagno

Do not wish ever to use that fantasy.
Make yourself great in trickery
If you wish for success in this art
That will bear good fruit.

Ancora nota et intende questa parte	Note well and understand this part
Chi vol de larte atuctu contrastare	Who wishes of the art to act in opposition
De le mille una inbratara sue carte	Of a thousand, one will dirty his cards.
Cusi perde lhonor per un sol fallare	He loses honour for one single failing
Tal crede star di sopra che e di sotto	If he believes low things to be high
E questo sole spesso altrui scontrare	And from this alone will be often against others.
Spesso si fa conesso altrui barbotto	Often he makes from this other complaints
Contrastando se vene acustione	Being in opposition he comes to quarrel
Demostra qui cului che in larte i dotto	Showing that with him who is versed in the art
Se la ligua tagliasse per ragione	If the tongue could cut with reasons,
Et fesse ancora lei come la spada	And strike as does the sword,
Seria infinite morte le persone.	The dead would be infinite.
Et fa che de la mente tua no cada	And make sure your mind does not fall
Che piglie con ragion el tuo defendere	But grasp with reason your defence,
Et con iustitia iustamente vada.	And with justice go justly.
Chi vol senza ragion altrui offendere	If you go without reason to offend others,
Danna lanima el corpo certamente	Certainly damns his soul and body
Fa alsuo maestro vergogna prendere	And makes his master ashamed.
El te bixogna ancora avere amente	And you must always keep in mind
De portar sempre honere altuo maestro	To always honour your teacher,
Per che denar non paga tal somente	Because money does not repay such a debt.
Chi vol farsi signor de spada e destro	If you would be dextrous, and master the sword,
De inprendere et de insignare facci derata	You must be accomplished in teaching and learning,

E taglie et punte insegna el bem parare.	And cuts and thrusts, it teaches the good parry.
Quanti sonno senza numer morte.	How many are those, the numberless dead
Che larte non glie stato alor gradita.	To whom the art did not appeal,
Pero an de uita chiuse le lor porte.	And so they closed their doors to life.
None magior texoro che la vita.	There is no greater treasure than life,
E per defeder quella ognium se ingiegna.	And everyone strives to defend it,
De mantenerla quanto po faita.	To hold onto it as hard as they can.
Lassa la robba et ogni cossa degna.	Abandon material goods, and all valuable things,
Defende conquestarte la persona.	Defend your body with this art,
Ne porte honore e glorioxa insegna.	And you will have honour and glory.
O Quanto e coxa laudeuole et bona.	Oh what a laudable and good thing it is
Apreder starte che to costa poco.	To learn this art that costs you so little,
E mille volte la vita te dona.	And a thousand times gives you life.
O In quanti modi la ti po avere loco.	Oh in how many ways it can have a place with you
Senza cercare se trova costione.	Without searching you will find quarrels
Beato e quel che spigne laltrui foco.	Blissful is he who can push the other's fire.

Folio 8R	Folio 8R

Larte mia nova et fatta con ragione.	My art is new and made with reason
Non dico de la vechia la qual lasso.	I speak not of the old, that I leave
Ai nostri antichi con lor opinione.	To our ancestors and their beliefs.
Se tu no vorai dhonore esser casso.	If you do not want your honour to be thrown down,
Misura il tempo tuo et quel conpagno.	Measure your tempo and that of the companion.

Questo e de larte fondamento epasso.

This is the foundation and base of the art.

Apre lorechie al documento magno.
E fa che intende le ragion si belle.
Per che non dagge altuo maestro lagio.

Open your ears to the great text,
And understand its beautiful reason,
To not give your teacher cause for complaint.

Fa che le spade sian sempre sorelle

Make it so the swords are always sisters

Quando tu viene ascrimir conalcuno

When you come to fence with someone

E dapoi piglia qual ti voi de quelle.

And choose the one you want from them.

N Non dar vantagio di spada aniuno.

Do not give advantage of the sword to anyone

Staresti apericolo davenne vergogna.

You will be in danger of being shamed,

Et questo equel che de sequir ciascuno.

And this is something to be followed by anyone.

Bonochio saper prestezza bixogna.

Good eye, knowledge, speed are needed,

Et se laforza el cor con seco sia.

And if you have strength and heart together

Farai grattar aciasschedun la rogna.

You will scratch anyone's mange.

Intende ben qui la senteza mia
Lhomo grande fa de spada longezza
Et picolomo la spada curta sia.

Understand my sentence well,
A big man should have a long sword,
And a little man should have a short one.

Gran forza dhomo le guarde si spezza

A man of great strength can break the guards,

Lingiegno natural li porgie elfreno

But natural cleverness will keep that in check,

Dona alpicolhomo bona francheza.

It gives a good chance to a small man.

Chi fa assai colpi si porta el veleno	Who makes many blows brings venom
Chi fa poco fa con gramfaticha	Who makes few does so with great effort,
Afin neroman vento e pur dameno.	In the end a black wind can be pleasant.

Folio 8V

Folio 8V

Et si tu vene el fil de la mia riga	And if you come to the edge of my line,
Et piglii di questarte la ragione	And grasp the reason of this art,
Atoi bixogna ti tora di briga.	She must extract you from trouble.
Et nota bem quel chel parlar qui pone	And note well that of which I speak,
Non palexare isecriti del arte	Do not display the secrets of the art
Che non sie offexo per cotal ragione.	So you won't be injured for this reason.
Ancora intende bem questaltra parte	Also understand well this other thing,
La spada che piu longa sie mortale	The sword that is longer is deadly,
Senza pericol con lei non poi adoprarti.	You cannot play with it without danger.
Fa che la sia ala mesura eguale	Make sure they are of equal measure,
Commo teo dicto nel capitol primo	As I said in the first chapter
Del nostro libro che de sopra sale.	Of our book, that is above.
La spada da doi mane sola stimo	I only esteem the sword of two hands,
Et quella sola adopro amia bixogna	And this is the only one I use at need,
De cui cantando nel mi libro rimo.	And of which the verse of my book sings.
Et tu non vorai aver vergogna	And so you will not be shamed,
Contra piu duno briga non pigliare	Avoid fighting more than one
Che farai verso daltro che sanpogna.	Who makes against the other one the reed-pipe.

Si forza te stregnersse avere affare	If force constrains you to contend
Con piu duno fa che te sia amente	With more than one, then keep this in mind,
De preder spada che la possi oprare.	Take a sword that you can really use.
Torai arma lieve et non pesente	Choose a weapon that is light, not heavy,
Accio che labii tutta in tua balia	So it is easily controlled
Che per grevezza non te porga stente.	And you are not given difficulty by the weight.
Alor bixogna che piglii altra via	At need you can take another way
Che tu lassi la punta et che tu adopre	And you leave the thrust and employ
Alteiferire por ritornare alquia	Other blows to return here,

Folio 9R	Folio 9R

Como udirai nella sentenza mia.	As you will hear in my text.

CHAPTER FIVE

OF THRUSTS AND CUTS

THIS REPEATS THE previous mention of the blows in chapter III, asserting that there are seven in total (as Fiore says too), and the sword has two edges (false and true) and a point. Strike forehand with the true edge, backhand with the false, and all descending blows with the true edge. As far as I can tell this doesn't actually add anything to the chapter III material, but serves as repetition. Chapters VI and VII will repeat this material again, and add characterisation to the blows.

Capitolo V	Chapter V
De punte e de tagli	Of Thrusts and Cuts

La spada sia una ponta con doi taglie	The sword has a point and two edges,
Pero bem nota et intende questo scripto	But note well and understand this text,
Che la memoria tua non sabarbaglie	That memory will not fail you.
Luno sie el false et laltro sie el dirito	One is the false, and the other the true,
E la ragione si comanda e vole	And reason commands and desires,
Che questo tenghe nel cervel tuo fitto	That this is fixed in your brain.

Deritto col deritto inseme tole	Forehand and true edge go together,
El riverso col falso inseme sia	Backhand and false edge stay together,
Salvo el fendente lo diritto vole.	Except the fendente which wants the true.
Intende bene la scriptura mia	Understand my text well,
Sepetti colpi son che la spada mena	The sword goes with seven blows
Sei taglii con la punta quel feria	Six cuts with the thrust that strikes.
Accio che du ritrovi questa vena	So that you will find this seam,
Doi de sopra et de sotto e dui mezane	Two from above and below and two in the middle,
La ponta por mezzo con ingagne et pena	The thrust up the middle with deceit and suffering,
Che laer nostro sa spesso serena.	That our Air is often calm.

CHAPTER SIX

THE SEVEN BLOWS
OF THE SWORD

HERE VADI GOES into some detail regarding the blows, describing their actions and in some cases what works against them. Though he names the chapter "the Seven Blows of the Sword" he only describes the six cuts here, splitting the thrusts off into their own chapter (VII). It makes a certain numerological sense – chapter 6 describes six cuts, chapter 7 describes the seventh blow.

For Fiore scholars the most interesting part is perhaps the text regarding the fendenti blows. Not only is this the only cut that has the same name, but the text describing them is almost word for word identical with Fiore's:

Vadi:	Fiore (folio 23):
Semo fendente et famo costione	Noy semo fendenti e in larte fazemo questione
De fendere et tagliare spesso con pena.	de fender gli denti arivar alo zinochio cum rasone.
Testa e denti con diritta ragione.	Eogni guardia che si fa terrena, duna guardia in laltra andamo senza pena.
E dogni guardia che fa fa terrena	E rompemo le guardie cum inzegno.
Rompemo spesso con lo nostro ingiegno	Ecum colpi fazemo de sangue segno.
Passan da luna et latra senza pena.	Noi fendenti dello ferir non avemo tardo.
	E tornamo in guardia di vargo in vargo.

Colpi facem de sanguinoso segno
Se noj ne mescolamo con la rota
Tutta larte farem nostro sustegno.

Fendente de ferir noi damo dota
Tornamo inguardia ancor di varcho in
varcho
Tardi nonsemo de ferir qui nota.

The English translations look like this:

Vadi:	Fiore:
We are the fendenti and we make quarrels,	We are fendenti and in the art we make quarrels.
To strike and cut often with grief,	We break the teeth and arrive at the knee with reason.
The head and the teeth with the right reason.	And (break) all low guards.
	We go from one guard to another without difficulty
And all guards that are made low to the ground,	And break the guards with cunning
.We break often with our cunning,	And with blows we make a bloody mark,
Passing from one to the other without trouble.	We fendente that are not slow to strike.
	We return to guard from step to step.
The blows make a bloody mark,	
When we mix them with the rota	
We support the entire art.	
Fendente for striking we are well endowed,	
Returning to guard from pass to pass,	
Note we are not slow to strike.	

Interestingly, for literary scholars anyway, Vadi ends this chapter with a change from the usual alternating rhymes arranged in three line stanzas to a six-line block which ends with a couplet.

In summary, the key points for these blows are:

Fendente (descending bows):
1. It starts fights (makes arguments)
2. It smashes and cuts heads and teeth
3. It breaks low guards (so can be used against them)
4. It strikes by stepping from guard to guard.
5. It leaves a bloody mark
6. It should be mixed with rising blows.

Rota (rising blows):
1. Strikes hard (has in me such a load)
2. Should be mixed with the other blows
3. Not courteous or loyal
4. Returns with a fendente
5. Destroys the arms and the hands.
6. Requires the false edge.

Volante (horizontal blows):
1. Always crossing (so, strike horizontally)
2. Strike from the knee up
3. Can parry fendenti and thrusts
4. Are crossed (parried) by rota blows which return with a fendente to strike.

Striking "from the knee up" is interesting, and echoes Fiore (who wrote "*E nostro camino sie dello zinochio ala testa*" (Our path is from the knee to the head)). I have always interpreted this to mean that the blow is made by striking up from a low guard, because in Fiore we never see a successful mezano done any other way, with the possible exception of the mezano feint that begins the play of the punta falsa (17th play 2nd master zogho largo). The text is ambiguous in both cases, and it may mean that the target is from the opponent's knee, up. But earlier on folio 23, Fiore wrote regarding the sottani: *cominzamo alo zinochio e andamo por meza la*

fronte por lo camino che fano gli fendenti (we begin at the knee and go to the middle of the forehead by the same path that the fendenti make), which is refreshingly straightforward: we know that these blows, at least, begin at our knee and end in his head.

Capitolo VI	Chapter VI
Lisepri colpi de la spada.	The seven blows of the sword.

Semo fendente et famo costione	We are the fendenti and we make quarrels,
De fendere et tagliare spesso con pena.	To strike and cut often with grief,
Testa e denti con diritta ragione.	The head and the teeth with the right reason.
E dogni guardia che fa fa terrena	And all guards that are made low to the ground,
Rompemo spesso con lo nostro ingiegno	We break often with our cunning,
Passan da luna et latra senza pena.	Passing from one to the other without trouble.
Colpi facem de sanguinoso segno	The blows make a bloody mark,
Se noj ne mescolamo con la rota	When we mix them with the rota

Folio 9V	Folio 9V

Tutta larte farem nostro sustegno.	We support the entire art.
Fendente de ferir noi damo dota	Fendente for striking we are well endowed,
Tornamo inguardia ancor di varcho in varcho	Returning to guard from pass to pass,
Tardi nonsemo de ferir qui nota.	Note we are not slow to strike.

Io so la rota et tenogo ime tal carcho.

I am the rota and I have in me such a load,

Se con altri colpi me vo mescholare:

That you want to mix me with the other blows,

Io mettero la punta spesso alarcho.

I place a thrust often at a bow.[1]

Lielta et cortesia non posso usare
Rottando passo per deritte fendente

I cannot be courteous or loyal
Turning I pass through forehand fendente

E guasto braccia e man senza tardare.

And destroy arms and hands without delay.

Rota me chiama por nome la giente
La falsita de spada vo cercando
Chi madopra gliaguzzo la mente.

People call me Rota by name,
I seek the false of the sword
I please the mind of he who uses me.

Semo volanti sempre atraversando
E dalgienochio in su el nostro ferire
Fendente et punte spesso ne dabando

We are volanti, always crossing
And from the knee up we go,
Fendente and thrusts we often banish.

Per traveso noi passa anon falire
La rota che desotto insu percote
E cole fendente ne scalda legotte.

By crossing us pass without fail,
The Rota that come up from below,
And with the fendente warms our cheeks.

CHAPTER SEVEN

THE THRUST

THIS VERY SHORT chapter simply states that the thrust is a good technique. There is no real discussion of its use – in fact we learn more about when to use it, and how to counter it, elsewhere. That chapter seven, dealing with the seventh blow, has seven lines, is probably deliberate.

Capitolo VII	Chapter 7
De la punta.	Of the thrust.

Io son colei che facio custione	I am he that quarrels with
A tuti i colpi e chiamome la punta	All the other blows, and I am called the thrust.
Porto el veleno como el scorpione.	I carry venom like the scorpion.
Et sentomi si forte ardita et pronta	I feel so strong, bold and quick,
Spesso le poste factio sua riare	Often I make the guards plough again
Quando altri pur me getta et chi safronta.	When I am thrown at others and confront them
Et per mal tocco nium quando sun gionta.	By my harmful touch, when I join them.

CHAPTER EIGHT

THE QUARREL OF THE CUTS AND THRUSTS

THIS CHAPTER STARTS as a conversation between the blows, where the cuts gang up on the thrust. It has the makings of a pretty conceit, quite common in medieval literature. The title, "The quarrel of the cuts and thrusts" clearly sets us up to watch a play in which these blows will argue their merits against each other, and the first two stanzas do not disappoint. The blows trash-talk the thrusts, pointing out that they are easily beaten aside by all three types of blow. This gives way though to a straightforward description of the merits and usage of the blows, especially the thrust.

The main points:

1. The thrust is easily beaten aside by any blow
2. If it misses, the thrust does not automatically chamber a new blow (which cuts do)
3. The thrust should only be used against a single opponent, not against multiple opponents
4. The thrust must exit as fast as it enters or it gives the opponent a tempo to strike in
5. The thrust can be beaten to the ground (with the "low cross")
6. The chapter finishes by describing putting the opponent under pressure with a fendente.

The overall impression given is that the thrust, while very dangerous if it lands, exposes the user to excessive risk.

Folio 10R	Folio 10V
Capitolo VIII	Chapter VIII
Costione di tagli et punte.	The quarrel of the cuts and thrusts.

La rota coi fendente et coi volante	The rota with the fendente and the volante
Dicon contra le ponte et si li mostra	Say to the thrusts ""we will show
Che le non sonno pricoloxo tante.	That you are not so dangerous".
E Quando vengon ala presentia nostra	And when they come to us,
Tucti icolpi gli fan smarir la strada	All the blows can make them lose their way
Perdendo pur el ferrir perquella giostra.	Losing in this joust the chance to strike.
Non perde volta el coplo de la spada	The blow of the sword does not lose its turn,
Pocoval la punta achi presto volta	Little worth the thrust to him the quick turn,
Se fan far largo icolpi pur chivada.	It makes it go very wide, the blows going that way.
Si tu non hai la memoria sciolta	If you don't have a slack memory,
Se la punta no fere perde el trato	If the thrust doesn't strike it loses the strike
Tute glialtri ferrir la tene scolta.	All the others deem it weak.
Contrar un sol la punta trova parto	Against just one the thrust finds its place,
E contra piu non fa gia il suo dovere	Against more it doesn't do its duty,
Questo rechiede el documento et latto	This is found in the text and the act.

Se punta butta rota non temere	If the thrust throws a rota do not fear
Se subito non piglia el bom fendente	If it does not immediately take a good fendente,
Remane senza fructo al mio parere.	It remains fruitless against my parry.
Qvi fa che ponghe un poco la tua mente	Keep in mind here,
Se punta intrata non na presto usita	If the thrust enters but does not swiftly exit,
Te fa el compagno deferrir dolente.	It lets the companion strike back hard.
Tagliando un colpo tua spada eperita	Your sword is expert at slicing a blow,
Se punta nel ferrire perde strada	The thrust will lose its way to the strike,
On derita croce di sotto taita.	It is mocked with the help of the low cross.
Ricto fendente farotte de spada	I make a straight fendente at you with the sword,
Ettrarotte de tal posta fora	And break you out of that guard.

Folio 10V

Folio 10V

Accio che in mal punto tu tenvada.	So that you are forced into a bad spot.

CHAPTER NINE

THE CROSS

HERE VADI STATES that the cross, which here means the parry done by crossing your opponent's weapon with your own, is the core of your defence. He explicitly connects the cross you make with your sword, which will save you from death, with the cross of Jesus, in which every Christian would see his salvation from eternal death. This is more than just a coincidence – Vadi is deliberately tying his art to the knight's religion. It is worth bearing in mind that while Vadi was writing this book in Italy, the Christian knights in Spain were busy driving the Moors off the Peninsula.

Capitolo IX	Chapter IX
De la Croce.	Of the Cross.

Io son la croce col nome de iesu	I am the Cross with the name of Jesus
Che dereto et denanti uo segnando.	My sign is made both in front and behind
Per retrovare molte defexe piu.	To find many more defences.

Si con altrarma io me uo scontrando	If I find myself against a different weapon,
Non perdo camin tanto son de prova	I do not lose my way, this has been proven
Questo spesso maven chio el uo cercando.	This I often go looking for.
Et quando unarma longa si me trova	And when I find a long weapon,
Chi con ragion fara la mia difexa	Then with reason I make my defence,
Ara lhonore de ciascaduna inprexa.	To gain the honour in every venture.

CHAPTER TEN

ORDERING THE HALF-SWORD

"RAGION DI MEZA spada" contains both some of the most cryptic, and some of the clearest, longsword material. Once the cross has been established, one way or another, there is a specific set of actions to be taken depending on the exact nature of the cross. The meza spada is the crossing of the swords at the middle of the blades. Fiore organised his sword plays according to the nature of the crossing that precedes them, and describes crossing at the tips of the sword (punta di spada), at the middle of the swords (meza spada), and near the hilts (a tuta spada). Of these three, by far the most variation happens at the meza spada. This crossing is divided into two types: zogho largo, in which you are basically free to leave the crossing to strike, and zogho stretto, in which you are constrained by the threat of your opponent's weapon and so must pass with the cover and come to the close play. Vadi's meza spada seems to focus on this latter condition. Because Vadi is using a longer sword he is able to apply a range of strikes that Fiore, with the slightly shorter swords, could not. It is worth noting that all 25 of Vadi's illustrated longsword plays can be done from a meza spada crossing that satisfies the main conditions of zogho stretto: points in presence, pressure in the bind, crossed at the middles.

We will see later that Vadi distinguishes between the strikes done in mezo tempo (half time) and the 'normal' strikes of the sword in two

hands. Interestingly, here he begins with actions that appear to be done from wide measure, long before the crossing has occurred. He starts by stating he will make clear the turning principle of the sword, then just tells us to go with the arms extended and bring the edge to the middle of the companion. He then gives some fairly general, and some very specific, instruction. I have yet to find the organisational theme here.

The main points are:

1. With the arms extended, bring your edge to the middle of the companion. (i.e. Keep your sword in front of you.)
2. Go from guard to guard with a serene hand. This is a lovely way to describe striking, and one of the most often quoted lines in class.
3. Do a stramazone by making a small turn in front of your face.
4. Long motions don't work.
5. Strike a roverso while passing offline with the left foot, right foot follows. Watch out for his parry.
6. To enter into half-sword, do it when the opponent lifts his sword (to parry?). Grab the tempo.
7. From the boar's guard, enter with a thrust followed by a roverso fendente then a mandritto. (This echoes Fiore's description of the boar's tooth guard on folio 24r)
8. Don't use just roversi, nor just fendente, but mix them up.
9. When entered, you want to have the same foot forward as your opponent.
10. When striking a roverso (from the crossing) bend your left knee and extend your right leg.
11. Remain on the diagonal
12. When striking a mandritto, bend the right knee, extend the left leg.
13. This is not the "footwork of our ancestors": Vadi is claiming (again) that this is a new art.
14. Make war with shorter movements

The section made up of the last six stanzas of this chapter is perhaps the most cryptic and hard to apply of any in this entire book. Imagine that you have entered, and you and your opponent are both right foot forward (which is the most common arrangement at the meza spada). If I strike a roverso from here, but shift my weight to my back leg, I am out of measure. If I step according to the instruction at point 5, then it works fine, but then if I am supposed to strike a mandritto by just bending my right knee, I am again out of measure. I don't believe Vadi wants us to stand square-on and simply swing from side to side – it is way too vulnerable, and contradicts his instruction in Chapter 3 to "remain side-on". He also mentions here (which I have left out of the numbered points above) about the opponent attacking your head, which has something to do with which leg is forward. Witness:

Clearly the head will also be attacked,
With the right foot that is closest.
This is the better way.
This is not the footwork of our ancestors.

Perhaps he means we attack the opponent's head, and use whichever foot is closest to determine which blow to strike?

| Capitolo X | Chapter X |
| Ragion di meza spada. | Discussion of the half-sword. |

Volendo nui seguir questa degna opra	Wanting to follow in this great work,
Bixogna dechiarar aparte aparte:	It is necessary to explain bit by bit,
Tutti iferir de larte.	All the strikes of the art.
Accio che bem se intenda et che sadopra	So that you will understand and use
La ragion vol che prima ve descopra	The system well, I wish to first make clear

Del rotare principio de la spada	The turning principle of the sword.
E Con braccia stexe vada	And with arms extended

Folio 11R

Menando el fil per mezzo del compagno.	Bring the edge to the middle of the companion.
Et si tu voi parer nellarte magno	And if you wish to appear great in the art,
Tu poi andare alor de guardia inguarda	You should go from guard to guard,
Con man serena et tarda	With a slow and serene hand,
Con passi che no sian for del comuno.	With steps that are not out of the ordinary.
Si tu fascesti stramazzone alcuno	If you wish to make a stramazone at someone
Faral con poca volta nanti alvolto	Do it with a small turn to the face
Non far gia largo molto	Don't make a very wide turn
Perche ogni largo tempo sie perduto.	Because all long movements are for nothing.
Fa chel reverso te sia poi in aiuto	Making the roverso you will be helped,
Passando for de strada colpe stancho	Passing out of the way with the left foot,
Tirando el derito ancho.	Following with the right foot too,
Avendo lochio sempre albem parare.	Keeping an eye out for a good parry.
Quando vorai amezza spada entrare	When you wish to enter in to half-sword
Commo el compagno leva la sua spada	As the companion lifts his sword,
Alor non stare abada	Then don't hold back,
Tempo pigliar che non te coste caro.	Grab the tempo or it will cost you dear.
Fa che tu sie in guardia decenghiaro	Place yourself in the guard of the boar,
Quando tu entre con la punta aluixo	When you enter with the thrust at the face

Non star punta divixo	Do not leave your point in the face,
Voltando presto el riverso fendente.	Turn quickly a roverso fendente.
Etira el deritto et fa te sia amente	And draw a mandritto, and keep this in mind.
Accio che intende la mia intentione	So that you understand my intention,
Con chiara ragione	With clear reasoning,
Spero mostrarti interamente el verso.	I hope to show you the way.
Non vo che intucto sia puro riverso	I don't want your blows to be solely roverso,
Ne sia fendente ma tra laltro eluno	Nor just fendente, but between one and the other,

Folio 11V	Folio 11V

Si tra quel comuno.	If between is the common one.
Martelando latesta in ogni lato.	Hammering the head on all sides.
Ancor tavixo quando serai intrato	Also I advise you when you have entered,
Che con le ganbe tuta concii paro	Be with the legs paired with his
Serai Signor et chiaro	You will be lord, and clear,
De stregnere et ferire arditamente.	To constrain and strike valiantly.
Et quando trai el riverso fendente	And when you strike a roverso fendente,
Piga el gienochio stanco et nota el scripto	Bend the left knee, and note the text,
Destende el pie derito,	Extend the right foot,
Senza mutarlo alora in altro lato.	Without changing it, i.e. to the other side.
Alora se intende assere atacato	Also, if you see you are going to be attacked,
El pie stanco con la testa adesso	The left foot and the head now,
Per che li sta piu apresso	Because they are closer together,
Che non fa el ritto che roman traverso.	So don't use the direct line, but remain on the diagonal.

Alor tu sei segur per ogni verso	So you will be safe from every side,
Ese voi el fendente ritto trare	So you want the fendente, strike from the right,
Te bixogna pigliare	You need to bend
El gienochio ritto: et stende ben el stancho.	The right knee: and extend well the left.
Chiamarasse la testa atacata ancho	Clearly the head will also be attacked,
Col pie diritto che glie piu vicino	With the right foot that is closest.
Questo e meglior camino.	This is the better way.
Che none el passeggiar di nostri antichi.	This is not the footwork of our ancestors.
Non bixogna chalcum contrasti odichi	It is not necessary that anyone contradict this,
Perche tu sei piu forte, et piu seguro	Because you will be stronger, and more secure,
Ala difexa duro	Hard in defence,
Et con piu breve tempo afar la guerra.	And make war with shorter movements.
Ne non po farte ancor chasschare interra.	And neither can anyone throw you to the ground.

PRINCIPLES OF SWORDPLAY

THIS CHAPTER IS a marvellous blend of crossing-specific responses, drills from set guards, and general remarks. I'll summarise the main points as usual, then flesh out the most important ones. Fo clarity, I have divided the chapter into parts – please note that Vadi does not.

Part one: when joined at the half-sword:
1. Strike a mandritto or roverso.
2. Be quick to cover
3. Hold the sword up so your hands play above your head.

This is a fascinating set of instructions. At this crossing, Fiore would have us enter, as has been discussed before. Vadi's first choice is to strike, on one side or the other – presumably whichever side is open. He will discuss the use of feints to create an open side in the next chapter. Because your opponent's sword is close to you, you must be careful to keep the line closed – to cover. And you can raise your sword, keeping contact with his, and strike with your hands above your head, in a winding action as is commonly shown in the German manuscripts.

Part Two:

If this is all too much, you can just:

4. Parry with a fendente
5. Beat his sword to the ground

When parrying, you should:

6. Parry a roverso with your right foot forwards
7. Parry a mandritto with your left foot forwards.

This begs the question of how do you know which way the attack will come in? Either you must anticipate it from the opponent's guard position, or you must be able to switch your feet as needed when parrying. This can not be reasonably done from a normal, wide based stance: but is easily accomplished from any of the narrow based stances we see in Vadi's guards Falcon, Sagitaria, Fenestra, and Frontal on folios 16V-17V. (This insight came from my student Frank Polenz.)

Part Three:

8. When attacking with a roverso fendente, watch out for a mandritto from your opponent.
9. If he tries to strike, parry, and strike a false edge blow to his head.
10. When he tries to lift your blow (beating it up to parry), strike a good roverso from below across his arms, redoubling with a mandritto.

Here is a lovely and very specific drill. It starts with your roverso, against which your opponent counterattacks with a mandritto. So we can set this up with you in a left-side guard such as frontal, and your opponent in a right side guard such as mezana porta di ferro (note that I am referring to these guards as Vadi shows them, which is very different to Fiore's versions. Please refer to the guards chapter for details), and follow the play from there. I have written it out as a set drill here:

1. Stand in frontal, sword high on the left. Partner is in mezana porta di ferro, sword low and to his right.
2. Attack with a roverso fendente, passing in with your left foot.
3. Partner counterattacks with a mandritto rota.
4. As his sword comes up, parry it, your sword deviates from the original line of attack to meet his blade.
5. Having parried, to your left, slice at his face with a roverso volante.
6. Partner parries, lifting his hands. He would probably continue from here to pommel strike.
7. Pass with your right foot to your right while letting your sword point wheel round to strike under his arms with a roverso rota,
8. And strike again with a mandritto fendente.

You can find a video of this interpretation here: http://www.swordschool. com/wiki/index.php/Vadi_Chapter_11

Part Four:
11. When attacking with a mandritto fendente, watch out for his roverso.
12. If he strikes a roverso, parry it with a fendente.

This is the same basic idea as the previous drill, just done on the other side. Our current working version of this is on the same page of the wiki.

Part Five:
13. You can just enter in underneath, grabbing his handle and hammering his moustache with your pommel.

What we have here then are the basic responses to the meza spada (strike on one side or the other, or wind), followed by a series of ways to avoid it (beat his sword down) and some specific instructions on attacking, and

finally an instruction, in the tone "well if all else fails, just…" to enter in, grab his hilt and smash him in the face.

Capitolo XI	Chapter XI
Ragion de giocho de spada.	Principles of Swordplay.

Qvando tu sei amezza spada gionto.	When you are joined at the half-sword,
Facendo tu el diritto o voi el riverso.	Make a mandritto or roverso,
Farai che piglie el verso.	Be sure to grasp the sense
Di quel chio dico poi che sei al ponto.	Of what I say, because it is to the point.
Si tuui steggie tien pur lochio pronto	If you are there, keep a sharp eye out,
Et fa la uista brive con coverta.	And look quickly with the cover,
Et tien la spada erta.	And hold the sword up,
Che sopra el capo tuo le braccie gioche.	So your arms play above your head.
Non posso dire con parole poche.	I cannot say in a few words,
Perche gliefecti son de mezza spada	Because the matter is of the half-sword,
Accio che piu tagrada.	So that you will be better pleased,
Quando tu pare, para defendente.	When you parry, parry with a fendente.
S costa la spada un poco acortamente.	Brush aside the sword, a little shortened,
Date calcando quella del compagno.	Treading on that of the companion,
Tu fai pur bon guadagno.	You will make a good deal,
Parando bene icolpi tucti quanti	Parrying well however many blows.
Qvando pare el riverso porgie ananti.	When you parry the roverso, keep in front,
El destro piedi, et pare come dicto.	The right foot, and parry as I have said.

Parando tu el derito.	Parrying the mandritto,
Porai inanzi poi el tuo pie stancho.	Keep 7in front your left foot.
El te bixogna aver lamente ancho.	You should also keep in mind,
Quando tu trai el riverso fendente.	When you strike a roverso fendente,
Aver lochio prudente.	To keep a careful eye out,
Chil man diritto non venisse sotto.	So that a mandritto doesn't come from underneath.
Et si el compagno tresse et tu de botto.	And if the companion strikes and you all of a sudden
Para facendo poi ala testa cenon.	Parry, making then to the head

Folio 12V

Folio 12V

Col filo falso et col senon.	A blow with the false edge
Commo lalza tira el bom riverso	And as he lifts it, strike a good roverso
De sotto in su le braccia sua atraverso	From below, through his arms,
Redopiando poi el deritto presto.	Redoubling then with a quick mandritto,
Et nota ancor questo.	And note also this,
Che tu non falle la ragion de larte.	That you do not fail the Reason of the Art.
Si tu traesti el diritto alora guarte.	If you strike a mandritto, then beware,
Dal man riverso suo che non te dia.	His roverso so he doesn't strike you,
Fache tua spada sia	Make it that your sword
Colfendente aparar che non te coglia.	Parries with a fendente, so you are not caught.
E se pur te venisse alora voglia.	And if it comes to you then to want
De intrar sotto et pigliar suo mantenere	To enter underneath and grab his handle.
E farli poi el dovere.	And then do your duty,
Col pomo martlando alsuo mustaccio.	Hammering his moustache with your pommel,
Guardando bene che tu non piglii inpaccio.	Being very wary that hindrance does not grab you.

CHAPTER TWELVE

DISCUSSION REGARDING THE FEINTS OF THE SWORD

FOR THE FIRST time in Italian fencing literature we have a proper term for feinting, and a discussion of the use of feints. We know of course that Fiore used them – he describes what amounts to a feint in the play of the punta falsa, and he refers to guards such as longa and bicorno using deception. Both these guards for instance "avoid blows" (schiva gli colpi), which as a parry is usually done as a blow against the blade, suggests using these guards to feint with. The normal Italian term for feint is finta, a word conspicuous by its absence here. Instead, Vadi uses vista, which would normally mean "sight", and the verb visteggiare, which while it makes sense as a verbification of a noun, is not in normal usage. I'm guessing that this usage comes from the way feints work by showing the opponent a blow – making sure he catches sight of it and so parries as you wish. I (and Mele and Porzio before me) have translated the word as feint because from the context, that is clearly what Vadi is referring to.

I would paraphrase the first two stanzas like so:

The feints are done from the meza spada crossing. They call out from one side or the other, to hide their true nature from the defender. Do not let him understand where you are coming from. They shout to lie!

The rest of this chapter is essentially padding: I can't show you in

words etc etc., but study my teachings, be brave and cunning, become great in the Art. I love the image of the Art as a river, and the scholar as one studying its banks and depths. This tallies nicely with the way in which we as scholars must study broadly, learn every play; then go deep and become really good at the few key elements that work for us.

C. XII	Chapter XII
Ragion verso Viste de spada.	Discussion regarding the Feints of the Sword.

Ancor tavixo et notta el mio dir bene.	Again I advise you, and note my words well,
Che quando sei a mezza spada intrato.	That when you have entered into half-sword
Tv poi bem da ogni lato.	You then well from every side
Seguendo larte col bom visteggiare.	Following the art with good feinting.
S e chiamano le viste unofuschare.	Feints call out to obfuscate
Che ofisscha altrui nel defendere.	They hide from the other's defence.
Non lassa conprhendere.	Do not let him understand,
Quel che da un di lati vogli fare.	What you want to do from one side or the other.
Io no to posso cusi bem mostrare.	I cannot show you so well,
Col mio parlare como fari con spada.	With my words how to do it with a sword,
Fa che tu mente vada.	Make your mind go
Inuistigando larte col mio dire.	To investigate the art with my sayings.
Et pigliarai con le ragion lardire	And grasp valour with reason
Dapoi chio taminisscho et chio te insegno.	As I admonish and as I teach you
Et fa che con in giegno.	And do it with cunning

Tu segue quel che in tanti versi scrivo.

You follow that which I have written in so many verses,

Per retrovar nellarte el fondo el rivo.

To discover the depths and the banks of the Art.

CHAPTER THIRTEEN

PRINCIPLES OF THE HALF-SWORD

THIS CHAPTER CONTINUES the discussion of what to do at the half-sword, and follows directly on the previous chapter regarding feints by telling us straight away to strike on one side, and feint on the other. Having done that, decide whether you need to finish him off by closing in (and perhaps hammering his moustache with your pommel). The third stanza is especially interesting as it appears to have an expansion or explanation, done in the same hand but after the original was written. I've placed it in brackets to note that it is an addition. The main points are:

1. You are joined at the half-sword.
2. Strike on one side, feint on the other.
3. When he parries your feint, strike on the other side.
4. Finish by closing in, if needed.
5. Throw a roverso fendente, and when he parries, turn your point across his face, striking with the false edge.
6. Do not be divided from his point (i.e. Maintain your cover)
7. "Always enter with the point, forcing upwards from below"

This last point appears to be a way of avoiding the meza spada altogether. I don't see a way to do it from the crossing. It seems to follow the

instruction in chapter 3 to strike up from (for example) the Boar's guard, which prevents the swords meeting in the meza spada crossing.

You can see the action described at point 5 on video here: http://www. swordschool.com/wiki/index.php/Vadi_Chapter_13

C. XIII

Ragion de mezza spada.

Chapter 13

Principles of the half-sword.

Essendo tu pur gionto ameza spada	Being then joined at the half-sword,
Tu po bem piu et piu volte martelare	You can well hammer more and more times,
Da un sol lato trare	Striking on only one side,
Da laltra parte le tue viste vada.	Your feints go on the other side.
E Commo perde co parar sue strada	And when he loses his way with parrying,
E tu martella poi dalaltre parte	And you hammer then on the other side,
Alora tu comparte	Then you should decide
Q ua stretta te bixogna acio finire.	If you need to finish by closing in.
E e si pur tu volesti trar ferire	And if you want to throw blows,
Lassali andar el fendente riverso	Let a fendente roverso go,
E filo falso con la punta al vixo.	And a false edge with the point in his
(Voltandoli atraverso)	face (turning it across)
Non esser gia da lui punto devixo	Do not be divided from his point,
Col riverso o col dirito ancora	With roverso or mandritto
Con qual tu voi lavora.	With whichever you can work.
Pur che igienochie piglien da ogni lato	Because the knees bend on every side.
S Secondo che de sopra io mostrato	Following that which I showed you above,
Io te replico ancora questa gionta	I repeat for you again this addition,
S Enpre entra con la ponta	Always enter with the point,

Di sotto in su fino alvixo inforchando	Forcing upwards from below, finishing in the face
Eituoi ferrir adopra atempo quando.	And you can strike just at the right time.

CHAPTER FOURTEEN

PRINCIPLES OF THE HALF-TEMPO OF THE SWORD

IN THIS LITTLE chapter Vadi describes for us the way to strike safely from the meza spada crossing, using a "half time" or "half motion" of the sword. This may well be what Fiore refers to as a "meza volta of the sword", and action he mentions but never defines. Fiore's meza volta is a footwork action, defined thus: when with a pass forwards or backwards you can play on the other side. He goes on to say that there is a half-turn of the sword, but never refers to it in a way that would allow us to be sure what it is. Here, Vadi's mezo tempo blow is the means by which you can, from the crossing, strike safely on the other side of the opponent's sword. The key is to keep your hands in front of you, and turn the sword without losing your cover. As Vadi says, one who does not practice will parry badly, and thus get hit.

Up to now, the common interpretation of Vadi's *mezo tempo* has been a half-blow which (as the text says) treats as one the cover and the strike. In effect, a counterattack, or counter-cut, much like the Liechtenauer technique *zornhau ort*. This may be so, but does not fit with the rest of the book, nor with the repeated description that these blows "remain in a knot" or are "a turn of the knot". Executing these blows from the crossing though, we do simply keep our hands as a knot in front of us, and turn them from one side to the other.

We can cross-reference this to folio 15V, the blows of the sword in

two hands, which are illustrated as full blows (as in Fiore), and are specifically not those of the mezo tempo, as Vadi writes:

Qvesti son colpi de spa da due mane.
Non glie el mezo tempo: nel nodo rimane.

These are the blows of the two-handed sword,
Not those of the mezo tempo, they remain in a knot.

This may also exempt us from applying the injunctions about striking roverso volante and roverso rota with the false edge – these blows of the mezo tempo are mechanically different, and we will normally have to use the true edge even in these two cases to avoid losing the cover.

The key here is to keep your hands in front of you, and your sword between your face and your opponent's blade.

C.XIIII	Chapter XIIII
Ragion di mezzo tempo de spada.	Theory of the half-tempo of the sword.

Io non te posso scrivendo mustrare.	I cannot show you in writing
Del mezo tempo la ragione el modo.	The theory and method of the half-tempo
Perche roman nel nodo.	Because it remains in a knot
La brevita del tempo e delsuotrare.	The shortness of the tempo of his strike.
El mzzo tempo est solo uno suoltare.	The half time is just one turn
De nodo: presto et subito alferrire.	Of the knot: quick and immediately striking,
E raro po falire.	It can rarely fail
Quando le fatto con bona mesura.	When it is done in good measure.

Si tu noterai la mia scriptura	If you note well my writing
Mal se para chi non na la pratiche	One who does not practice will parry badly
Spesso la volaricha	Often the turning
Rompe con bom filo laltrui cervello	Breaks with a good edge the other's brain.
De tucta larte questo sie el givello	Of all the art this is the jewel,
Perche inun tracto el ferrissi et para	Because it treats as one the strike and the parry,
O quanto e coxa cara	Oh what a valuable thing,
A praticarlo con bona ragione	So practice it with good reason,
E facte portar de larte el gonfalone.	And it will let you carry the banner of the art.

CHAPTER FIFTEEN

PRINCIPLES OF THE SWORD AGAINST THE RISING BLOW

THIS CHAPTER WARNS against a certain kind of opponent, gives you a way to counter his preference, and to prevent him from being able to use his preference It also gives a very specific set drill, and then admonishes us to use the actions that we are most comfortable with. The main points are:

1. Some opponents base their technique in turning from side to side – i.e. Whirling their sword, such as in a figure eight.
2. Counter this by timing your movements to his, and making contact with his sword.
3. Alternatively, you can start in the Boar's guard and when he strikes a rota, strike upwards against it.
4. Or, you start in the archer's guard, your opponent is in the iron door; (as he moves) go out of the way, straightening your arms, so the sword and arms are in line. When the swords meet, you apply the 13th illustrated play.
5. Use only techniques which work for you: avoid any you find clumsy ("left-handed").

Let's separate point four out into a proper drill (this interpretation was arrived at in class by Janne Hurskainen and Johanna Laurikainen):

6. Start in sagitaria (archer's guard): feet close together, left foot forwards, sword horizontal, pointing forwards, about shoulder height.

7. Opponent is in one of the porta di ferro (iron door) guards, e.g. Porta di ferro la mezana: right foot forwards, sword resting on the right thigh, pointing down and to the right.

8. Opponent strikes a rota, aimed at your exposed left flank or head.

9. Step a little right with your right foot, uncrossing your arms and parrying with a fendente. Your left leg sweeps behind you.

10. Opponent turns his sword to enter with a punta falsa type action (e.g. The 12th play).

11. Lift your point and hook your hilt over his left arm

12. Cranking his elbow down by making a mandritto fendente type movement of the sword.

Note that to arrive at the picture (bottom illustration on folio 20r) we presuppose at least two actions on the opponent's part: the rota attack (implied in the title of the chapter) and the entry to the pommel strike, which the 13th play is clearly defending against. We are also assuming that the thirteenth constrained play here refers to the thirteenth illustrated play in the manuscript, which it may not, though I can't think of anything else it may be. Vadi does not divide up his plays into stretto (constrained) and largo (wide) the way Fiore does, but at this stage in the writing he may have intended to.

For video of this play, see here: http://www.swordschool.com/wiki/index.php?title=Vadi_Chapter_15

C. XV	Chapter XV
Ragion di spada contra la rota.	Theory of the sword against the rising blow.

Molti son chi fan lor fondamento.	There are many who make their base
Nel roteggiar bem forte da ogne lato.	In turning strongly from every side
Fa che tu sie avixato.	So be advised,
Como sua spada roteggiando moue.	As his sword turns, move.
E Tu roteggia et vincerai le prove.	And you turn and you will win the test,
Acordate con seco alor neltrare.	Harmonise yourself with him and also with the strikes
Et fa che sia tuo andare.	And make your going thus
Con la tua spada dereto ala sua.	With your sword directly to his.
Per chiarir meglio la fantaxia tua.	To clear your mind of illusions,

|

Ancor poi andar in dente de cinghiare.	You can also go into boar's tooth guard,
Et se lui col rotare.	And if he with the turning,
E tu scharpando pur de sotto in su.	And you escaping from below up.
O De et comprhende le mie ragione tu,	Listen and understand my reasoning,
Che sei novo nellarte et puro asperto.	You who are new to the art, and experts too,
E vo che tu sie certo.	I want you to be sure,
Che questa elarte et la scientia vera.	That this is the art and the true science.
Piglia questo che untracto di stadera.	Grasp this, that is a steelyard's trace,
Se stara el compagno in porta di ferro.	That if the companion is in the iron door guard,
Fa che tu sia in posta sagitaria.	You should be in the archer's guard,
Guarda che la punta tua non suaria	Watch out that your point does not waver,
Che del compagno copra la sua spada	That of the companion covers his sword;

Va un poco for de strada
Drizzando spada et mano con punta.

Go a little out of the way
Straightening the sword and the hand
with the point.

Qvando tua spada ala croce sia giunta.

When your sword is joined at the
crossing,

Alor fa la terza decima stretta.

Then do the thirteenth constrained
action,

Como tapare schietta.
Di pinta al nostro libro a sette carte.

As is you can plainly see
Pictured in our book of seven leaves.

Tv poi adoprar ancor in questa arte
Ferrire et strette che te sien piu destre

You can also use in this art
Striking and closing that are more
handy,

Lassa le piu sinestre.
Tiente aquel che la man te da favore
Che spesso te fara nellarte honore.

Leave the more left-handed,
Keep those that favour your hand,
So you will often have honour in the
art.

MASTERING THE SWORD

HERE VADI WRAPS up his ideas on the longsword with a summary of the key points to remember.

They are:

1. The sword should be a great shield, covering all.
2. Do not overreach, in guard or in striking.
3. Make only short movements.
4. Keep your point in the enemy's face.
5. Play forwards: i.e. Keep going towards the enemy. Every action should have a power component forwards.
6. Make small turns with a serene and nimble hand.
7. Break the opponent's tempo. i.e. Break his rhythm; break his movements; when he moves, hit him.

We should note at this point that every single word of Vadi's sixteen chapters of martial theory and advice has been to do with the sword, though in the illustrated portion of the manuscript he covers axe, spear, and sword in armour, and the dagger, as well. There are actually more illustrated plays of the dagger than of the sword (43 to 25). I think one of the reasons I enjoy this manuscript so much is that Vadi shares my priorities: dagger is necessary, and enjoyable

to practice, but the sword is where all the really important stuff happens.

C. XVI	Chapter 16
Amaestramento de spada	Mastering the sword

Bixogna che la spada site sia	It is necessary that the sword should be
Vm targone siecopra tutto	A great shield that covers all,
Folio 14V	Folio 14V
Or piglia questo fructo	And grasp this fruit,
El qual te don per tua maestria.	That I give you for your mastery.
Gvarda che mai spada tua non stia	Be sure that your sword does not
Facendo guardie ne ferrir lontana	Make guards or strike far away,
O quanto e coxa sana.	O how sensible this thing is,
Che la tua spada breve corso faccia.	That your sword makes short movements.
Fa che la punta guardi nella faccia.	Your point should watch the face,
Al compagno con guardie ouoi ferrire.	Of the companion, in guard or striking,
Tu li torai lardire.	You will take his courage,
Vedendoxe star sempre punta inante.	Seeing always the point staying in front of him.
E Farai el gioche tuo sempre davante.	And you will make your plays always forwards,
Cola tua spada et con picola volta.	With your sword and with a small turn,
Con man serena et sciolta.	With a serene and nimble hand,
Rompendo spesso el tempo del compagno.	Often breaking the tempo of the companion,
Ordirai tela daltro che di ragno.	You will weave a web different than spider's.

THE SEGNO

THE ART ON THE BODY, FOLIO 15R

THIS PAGE HAS excited much speculation and a certain glee for mystery and symbolism. This is entirely unnecessary, as Vadi clearly explains the meaning of the symbols. I have grouped them together sensibly, and go through them in order, from top to bottom. Note that there is no clearly ordered way to read this page, which is natural as it is intended as a visual aide-memoire, a kind of memory map, not as a dissertation.

It is very interesting to note that there was a coin made in 1457 by Giovanni Boldu for the Governor of Reggio, also called Filippo Vadi, which may or may not be the author of this MS. That coin clearly shows these symbols, in the same places: the callipers, the sword, the ram, the bear, the keys, the sun, the tower and the millwheel. There has to be some connection between the coin and the manuscript.

You can find the original article here: http://www.achillemarozzo.it/articoli/vari/storiavadi.php and a discussion of it in English here: http://hemaalliance.com/discussion/viewtopic.php?f=20&t=2129

1. Callipers: as callipers measure out the proportions of a piece by dividing it into parts, you should divide time into parts also. So, measure movement by dividing it into discrete units, and keep all movements in proportion.

Io sono sexto che fo partimenti	I am callipers, that divide into parts,
O scrimitore ascolta mia ragione	O fencer heed my reason,
Cusi misura et tempo simelmente	Thus measure the tempo similarly.

2. The Heart: this is an interesting notion – the eye of the heart, and one I have not encountered before. It is tempting to wander off into speculation about "feeling" your opponent, as in "trust your feelings, Luke", but really what we have here is a conflation of the mind (eye) being prudent and foresightful, as in Fiore's avvisamento/prudentia represented by the lynx and the callipers, and the heart being bold, as in Fiore's ardito/audatia represented by the lion and the heart.

Lochio col cor vole star atento	The eye with the heart should be alert,
Ardito e pieno di providimento	Bold and full of foresight.

3. Right shoulder: the right shoulder is characterised as a bear, which moves around, "sending your sword out to hunt". This is pretty clear, I think.

Il natural de lorso sie el girare	The nature of the bear is to turn,
In qua in la in su in giu andare	Going here, there, up and around
Cusi convene che tua spalla facia	Thus your shoulder should move,
Poii la tua spada fache metti in caccia.	Sending your sword out to hunt.

4. Left shoulder: the ram charges and butts with its head, and we can easily apply this when closing in – Right-handed swordsmen normally close in leading with their left side, and using the shoulder to barge the opponent is quite common. But note that cozare can also imply to deceive (think of the now-outmoded English word "cozen"). The next two lines clearly suggest that the

ram is not just a battering ram, as your "cut should be clever", and you should "always parry when there is an answer [to be made]". So, don't just barge in like a moron, smash your opponent intelligently.

Io so un muttone esto sempre amirare.	I am a ram, always on the lookout,
Che per natura sempre voglio cozare.	Naturally always looking to butt,
Così convien tuo taglio sia inginioso.	So your cut should be clever,
Sempre parar quando sera resposo.	Always parry when there is an answer.

5. Right hand: the "serpent", "prudent bold and deadly". Note that this serpent looks like a dragon, and indeed the terms are basically interchangeable here. Recall that the dragon in this period killed by lashing with its tail, not by breathing fire, and the correlation should be even clearer. Make your sword like the tail of a dragon!

La man dirita vol eser prudente	The right hand should be prudent,
Ardita emortale cum un serpente.	Bold and deadly as a serpent.

6. Left hand: can a) hold the blade of the sword for thrusting, as shown; b) manipulate the sword strike when the blades are crossed (joined). The strike must be quick as a greyhound (a popular hunting dog in this period, used for catching rabbits and small game) if it is to land. Correct use of the left hand is critical for these blows from the crossing.

Con la man stanca la spada o per punta	With the left hand, the sword is to thrust
Per far ferire dezza quando sera giunta	Or to strike when it is joined
E se tu voi sto ferir sia intero	And if you want the strike to be complete
Fa che sia presto como levorero	Make it as quick as a greyhound.

7. The legs and feet: the keys here echo the keys of St Peter we see on the coat of arms of the Duke of Urbino, and also on the Papal seal. They indicate that the knees must "open and close" or

bend and straighten, as Vadi talks about in Chapter 10. While stepping, one foot must stay firm, and the other one turn round it, as the sun turns around the Earth. (As a fool can plainly see.) This brings to mind Fiore's definition of the tutta volta: "*tutta volta sie qum uno va intorno uno pe cum latro pe, luna staga fermo e laltro lo circumdi*" ("the whole turn is when one foot goes around the other, one stays firm and the other turns around it."). The idea of the feet being on a wheel emphasises this, but does not fit well with Vadi's earlier descriptions of the legs bending and straightening without the feet moving. He refers again to the heart here, repeating the idea of foresight. Finally, the left foot is the one that must be firm. Why this is so eludes me, as clearly one must usually move whichever foot. Perhaps for a right-hander, who will normally lead with the left, most passes are done with the left foot fixed; or when we refer to his guards that have the feet close together, it should be the right foot that moves. This of does not square with the idea that you should select which foot you have forwards based on the line of the incoming attack (see chapter XI). I think this is a matter of emphasis: one foot or the other must be firm, and for right handers that may be more often the left one.

E chi queste chiave cum seco non avera.	And he who does not have these keys with him
Acquesto giuoco poca guerra fara	Will make little war with this play.
Tu vedi el sol che fa gran giramento.	You see the sun, that makes great turns,
E donde el nasce fa suo tornamento.	And where it is born it returns.
El pe com el sol va convien che torni.	The foot with the sun should return together,
Se voii chel giuoco toa persona adorni.	If you want the play to adorn your person.
Qvando ipie o luno o laltro fa molesta.	When one or other foot bothers you
Como rota da molin diavolta presta.	Turn it quickly like a mill wheel,

Bixogna esser il cor providitore.
C (…) lui saspetta vergona e lonore.

Le ganbe chiave se puo ben diri
Per che li ti serra e anche tipo aprire

E pie stanco ferma senza paura
Como rocha fa che sia costante
E poii la tua persona sera tuta sicura.

The heart must be foresightful,
That expects shame and honour.

The legs keys it is well said,
Because you close them and also
 open them,
The left foot firm without fear,
Make it constant like a rock
And then your body will be
 completely safe.

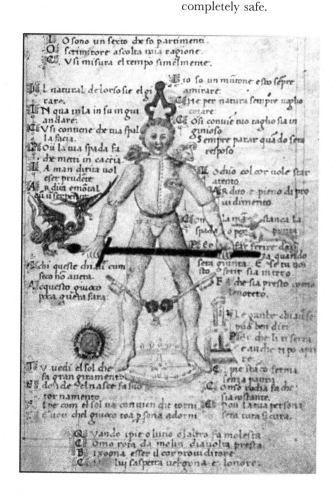

The Blows of the Sword

Seven Strikes, Folio 15 V

Qvesti son colpi de spa da due mane.

Non glie el mezo tempo: nel nodo rimane.

These are the blows of the
two-handed sword,
Not those of the mezo tempo, they
remain in a knot.

THIS IS THE example I use when explaining the need for the commentary in this book to prospective readers. The Italian here is clear, unambiguous, and even easy to read. Translating it is a breeze. The first line is pretty obvious, coming as it does above a picture of the paths the blows of the sword take. But the second line: what does it mean? Without a knowledge of the whole book, it makes no sense. But if we refer to the instructions in chapter XIV, it's clear. The blows described on this page are those done in wide play, when we are not working from the meza spada crossing. Those blows are different, and not shown (or even necessarily named) here. These are full, through-cuts, while the mezo tempo blows are smaller, staying in the centre, with the hands as a knot in front of you. It's possible that *nodo* means "wrist"; in the expression "*il nodo della mano*" ("the knot of the hand") it is exactly that; but outside that phrase, it seems not to. ("Wrist" is *polso*.)

In the early stages of my work on Vadi, done in the late nineties, my utter inability to read the text (my problems were due to the handwriting

and the language) lead me to teach a bunch of students that Vadi, in contrast to every other Italian fencing source we have that uses the term, calls the rising blow fendente. Let this be an object lesson to the reader: if your theory is based on just an image, but is contraindicated by abundant external sources, don't rely on it too heavily, it is probably wrong. If we compare this image to the Pisani Dossi ms, carta 12B, we see the rising and descending blows of the sword illustrated with identical upwards-point swords. In the Getty ms, folio 23r, we see fendente indicated by swords with the hilt uppermost, sottani with the hilts down. Here, Vadi indicates descending blows with swords pointing up, and ascending blows with the swords pointing down. There is clearly no one solid artistic convention in use. So we must read the text (note to self at age 26).

Rota: Clearly a turning blow that rises. I think of it as usually done with a mulinello. "Finding the falseness of the sword" is a reference to both feints and to using the false edge.

Io son la rota et uo spesso rotando	I am the rota and I often turn,
La falsita de spada uo cercando.	Finding the falseness of the sword.

Volante: These blows travel across. "From the knee up we go destroying" is very similar to Fiore's description of his mezani blows: Elo nostro camino sie dello zinochio ala testa (And our path is from the knee to the head). I interpret this to mean that the strike travels up and across from a low guard, not that you would use this blow anywhere above the knee on the opponent.

Nvii semo volante sempre traversando.	We are the volante, always crossing,
Dal ginochi in su andiam guastando.	From the knee up we go destroying.

Fendente: these "start the fight", so, we begin with one, and are aimed at the head, so "break the teeth". Breaking the teeth is a play on the word fendente, which while etymologically unrelated, sounds a lot like "fender gli denti" (as Fiore states), which means "to break the teeth".

Noii semo fendenti e facemo questione

We are the fendenti and we start the fight,

De fendere i denti con dirita ragione.

Breaking the teeth in our direct way.

Punta: the thrust, mistress of the other blows. Very many actions end with the thrust, and of all the blows it requires the least force to do lethal damage.

Io son la punta pericolosa e presta

I am the thrust, dangerous and quick,

De glialtri ferire sum suma maestra.

Mistress of the other blows.

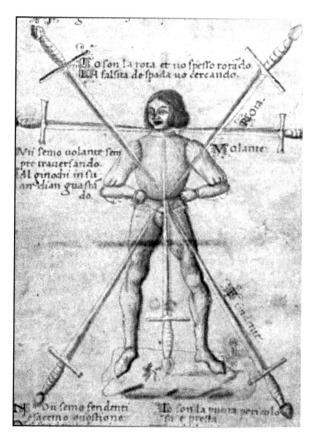

GUARDS OF THE SWORD

TWELVE POSTE, FOLIOS 16R-18V

THIS CHAPTER SET me off on an interesting sidetrack, to wit the idea that Vadi's guards represent a link between Fiore's system which preceded it and the Bolognese which succeeded it. There is no evidence, that I could find at any rate, that would suggest that Vadi's work was at all influential on the later systems, or indeed on his contemporaries. But it is highly likely that Vadi's work was generally representative of a trend in Italian swordsmanship in this period, a trend from which the Bolognese system developed. The sidetrack became a heavily illustrated article, which I have made freely available.

You can find the pdf of the article here: http://www.scribd.com/doc/104396013/Vadi-Guards

And the iBooks version with working galleries here: http://itunes.apple.com/us/book/italian-longsword-guards/id557522576?ls=1

Folio 16R

The guards of the sword appear after a portrait of the author holding a sword by hilt and blade. Oddly, the image appears under the text:

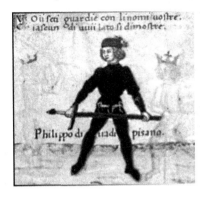

Voii seti guardie con linomi vostre.

Ciascun di uuii lato si dimostre.

Here are the guards with their names,

Each of your sides is shown.

Then under the portrait is the name:

Philippo di vadi pisano.

The first line is pretty clear, but the second is problematic. The problem stems from the word uuii, which Porzio and Mele appear to think is a variant on "voi", you (plural). They have it as "Each of you is shown side by side", which I cannot twist the text to fit. Ciascun is clear, si dimostre is clear, but di uuii lato is not. Lato means side, but might be l'atto, the action. "Each of your actions" would demand a plural here: latti. Likewise "each of your sides" would have lati. Shown from one side would come out as de un'lato, or similar. Fiore states that all guards can do a volta stabile (with both feet firxed you can play on the same side in front and behind) and a meza volta (where with a pass forwards or backwards you can play on the other side). In *Fior di Battaglia*, when high guards change sides they usually keep the same name (donna on the left, donna on the right) but low guards change: tutta porta di ferro becomes dente di zenghiaro. But the principle of there being an analogue for one guard on the other side seems to hold. Guards in the middle are obviously the exception – they can be held with either foot forwards but don't change side. I think that Vadi means that he is showing us the right and left side versions of each guard.

Middle Iron Door:

Son mezana porta di ferro forte.
Per dare con punte e fendente la morte

I am the strong middle iron gate
Dealing death with thrust and fendente.

In this guard the right foot is forwards and the sword handle is resting on the right thigh, with the blade pointing down to the right. It is similar to Fiore's tutta porta di ferro, but there the sword is in about same place relative to the body while the left foot is forwards. Note that the text here implies an offensive use of the position. In the third guard, also iron gate but held with the left foot forwards, the text mirrors Fiore's, and emphasises defence.

Guard of the Woman:

Io son posta di donna e non son vana
Che lungheza di spada spesso inghana.

I am the guard of the woman, and I am not vain,
I conceal the length of the sword.

Vadi's statement that it hides the length of the sword is interesting, as it apparently shows the sword clearly. But he is relying on an unfortunate aspect of the human visual system that makes it very hard to translate vertical measures into horizontal ones. It is actually hard to see how far your opponent can reach in this position. Note that this bears no real resemblance to Fiore's posta di donna at all, which is held on the right or left shoulder, very clearly chambering a blow.

Folio 16V

Iron Door, flat on the ground:

Son porta di ferro piana terrena
Che tagliae et punte sempre si rafrena

I am the flat ground iron door,
Always impeding cuts and thrusts.

This version of the iron door has the left leg forwards, and reproduces Fiore's first guard, tutta porta di ferro, quite precisely.

Guard of the Falcon:

Son posta di falcon suprana e altera
Per far difesa a ciascuna manera

I am the guard of the falcon, high up above,
To make defences in all sorts of ways.

This guard is excellent for parrying from, beating down any attacks. Note that Vadi does not suggest attacking from here; the guard appears to be purely defensive. Having the feet so close together allows you to very easily step to either side, adjusting your footwork to the line of the attack.

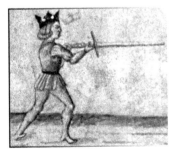

The Short Guard of the Extended Sword:

Son posta breve di spada longeza
Spesso ferisco con lei torno infreza

I am the short guard of the extended sword,
I often strike with the turn back.

This is guard is similar to fenestra and to bicorno, though it is odd that it should strike with a pass backwards. This must be either a counter-attack or a parry. Whether we strike from here, or into here, with the pass is unclear, though as a general rule all such instructions are "from" not "to". The sword is held so low that it offers no protection from any line of attack – it is perhaps inviting an attack against which it has a prepared counter.

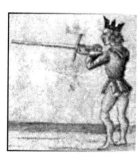

The Archer's Guard:

Son posta sagitaria por ingiegno
Uso mlitia assai nel mio regno

I am the archer's guard, to deceive
I use malice very much in my reign.

Though the text here is completely vague, Vadi does give us a specific play to do from here, in which you parry with a mandritto, swiftly uncrossing your arms. You can find it in Chapter XV. For video of this play, see here: http://www.swordschool.com/wiki/index.php/Vadi_Chapter_15

Folio 17R

The True Window Guard:

Io son la posta divera finestra
Leva de larte la cossa sinestra

I am the guard of the true window
I raise from the art the thing from the left.

This guard of course shares a name with Fiore's fenestra, and perhaps most interestingly includes the qualification "vera", true. This echoes the Novati text, where the full name of the guard is posta reale di vera

fenestra, the royal guard of the true window. In certain key respects Vadi shows his version differently: the sword is held pointing up, not horizontally, and again the feet are together. He will later show a left-side version and call it posta frontal. Note that Porzio and Mele translate the second line of the verse as "bringing the left thigh out of the art", which would imply that the left thigh has been withdrawn, as indeed it appears to be in the image. I don't at this stage have a working theory for what "the thing from the left" may be, but I conjecture it has to do with striking an upwards blow from the left which would create this position.

 The Crown Guard:

Io son corona eson fatta maestra
De legature mi ritrovo destra

I am the crown and I am made master
Of binds I am found to be adept.

This guard is clearly a version of Fiore's posta frontale, frontal guard. Fiore states that it is also called "corona", and as we can see from the images, it is held in much the same way. Vadi shows the guard right foot forwards; Fiore shows it the same way in the Novati, and left foot forwards in the Getty. Fiore's text is also useful here: he specifies that frontale is good for crossing swords with (e per incrosar ella e bona), which is similar to Vadi's statement that this is good for legature. Every bind is by definition a crossing, but not every crossing is a bind, and it is useful to remember that frontale is most commonly used in the moment of a parry from the right.

The Boar's Tooth:

Con mortal posta de denti cinghiare
Chi cerca briga assa glinposso dare

With the deadly guard of the boar's tooth
Anyone looking for trouble, I'll give them plenty.

This guard is closer to Fiore's mezana porta di ferro, held with the sword on the centre line of the body, than it is his dente di zenghiaro, which is on the left side. Vadi's text is the usual trash-talk: effectively "this is a good guard". It is clear though from previous references how the guard should be used. In Chapter X, for instance, it appears to be offensive:

Place yourself in the guard of the boar,
When you enter with the thrust at the face
Do not leave your point in the face,
Turn quickly a roverso fendente.
And draw a mandritto, and keep this in mind.

And in Chapter XIII, defensive:

To clear your mind of illusions,
You can also go into boar's tooth guard,
And if he with the turning,
And you escaping from below up.

The Long Guard with the shortened sword:

Son posta lunga cona la spada curta.
Che con lingiegno mio icolpi urta.

I am the long guard with the short(ened) sword,
That with my cunning defeats the blows.

This guard is perhaps closest to Fiore's posta breve. Fiore's usage is interesting: he states that this guard is always moving, looking for an opportunity to thrust, and is best used in armour. But Vadi's text suggests a more defensive application. The coiled position of the body in Vadi's image, turning to the left over the left leg, suggests to me a deflection leaving the point in line.

Folio 17V

The Frontal Guard:

Son posta frontal tanto sicura
De taglii e punte mainon faro cura

I am the frontal guard, so secure
Of cuts and thrusts I have the solution.

Vadi's suggestion here is that this guard defends well against cuts and thrusts, which is exactly how Fiore tells us to use his frontale. But the position itself is very different: this guard is closer to fenestra than in is to Fiore's frontale. My feeling is that in Fiore's frontale, this is the moment the blades meet; in Vadi's (and indeed in Fiore's fenestra), frontale is a position from which a parry is made. This ties in nicely with the situation on folio 31 of *Il Fior di Battaglia*, where a master in dente di zenghiaro waits to defend himself, and the text states he could be in any left side guard, such as donna on the left or fenestra on the left. Why Vadi doesn't call this fenestra on the left I don't know, but that is clearly what, from a practical perspective, it is.

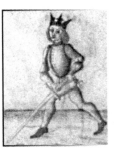

The Boar's Tooth, Outside:

Son posta posta di cenghiaro e son difora
Che de ferire mai non faro dimora

I am the guard guard of the boar and I am outside,
That of strikes I do not make a home.

This guard is, as the name clearly states, a variant on a previously illustrated guard, posta di dente di cingiaro. As with the previous poart di ferro guards, here we see the sword in about the same position relative to the body, but with the feet switched. It is interesting to note that in the Getty MS, but not in the other three extant MSs, Fiore also ends his twelve guards with a variant on dente di zenghiaro, though here the difference between the two is not a change of lead leg, but a volta stabile (stable turn) bringing the weight onto the back foot and the sword into the middle of the body. Fiore calls the latter posta di dente zenghiaro mezana, and states that the other is tutta, or full. (For an in-depth look at these terms, meza and tutta, please see my article on the subject here: http://www.scribd.com/doc/104773083/Half-full-Translating-Meza-and-Tutta-in-Il-Fior-di-Battaglia)

It seems to me that Vadi's statement that he will show you these guards on both sides is borne out; in fact he also shows several guards with either leg leading. His treatment of the low guards for instance includes right foot forwards and left foot forwards variants of both porta di ferro and dente di cinghiaro, and of his high guards, fenestra and frontale, sagitaria and posta breve di spada lungeza, are clearly left-right pairs. Dona, falcon, posta lunga con la spada curta, and corona appear to be standalone positions.

THE 25 PLAYS OF
THE LONGSWORD

FOLIOS 17V TO 23V

WITH THE POSSIBLE exception of the first play, I think that all of these plays can and should be done from the crossing at the middle of the swords, the situation that Vadi discusses at such length in Chapters IX to XV. It is, of course, possible to do them from a different starting point. The most common, and tactically simplest, way to generate this crossing is when one player attacks with a mandritto fendente, the other counterattacks with a similar mandritto fendente while stepping out of the way, and the original attacker manages to divert his attack to parry. The players end up with the swords crossed middle to middle, with the points in presence threatening the face, and some pressure in the bind. You can see our basic drill for creating this situation here: http://www. swordschool.com/wiki/index.php/First_Drill_zogho_stretto Normally, as the attacker is parrying, and we assume the parry works, he will end up with his outside line somewhat open, and his opponent's (the original defender's) inside line somewhat open. Vadi regrettably does not illustrate this position, but it is a commonplace in the other medieval longsword systems. In Fiore, it is the crossing of the zogho stretto; in the Liechtenauer, it is what happens when a zornhau ort is parried.

The fact that we find solutions here that echo the Liechtenauer system, but not Fiore, is interesting, and derives I think from the fact that Vadi

recommends a longer sword than the ones we see in most of Fiore's images.

In short, the swords being those few inches longer means that you are less likely to be close enough to enter into the grappling plays, and more likely to have time to strike on the other side of the sword, using one of Vadi's mezo tempo actions. We will see both types of play here; you would, I think, choose the one that best suits the measure you end up at, as well as the exact relationship between the blades. My working interpretations of these plays will be uploaded to the our syllabus wiki page bit by bit. You can find the page here: http://www.swordschool. com/wiki/index.php/Vadi_work_in_progress

Folio 17V

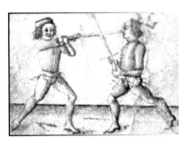

First play of the sword:

E reverso fendente ho tratto sul pe stanco
Senza scanbiar pe voltando el galone
Traro el dritto senza moverme anco.

I have made a roverso fendente on the left foot,
Without changing the foot turning the hips
I strike a dritto without further movement.

(No correlation to Fiore)
This has a very strange set-up with the player on the left standing left foot forwards, the player on the right, right foot forwards. Given the text, we assume the player on the left is following the instructions. This can be arrived at the following four ways:

1. He may attack with a roverso fendente, which if it is beaten wide from a left side guard (e.g. Boar's tooth) gives a follow-up attack of a dritto, striking either volante or fendente. This makes sense but does not lead to the crossed-hands position of the picture.

2. Alternatively, he may bind the parry, and immediately turn his hand over to strike a false edge dritto fendente. This follows the text and picture but violates Vadi's earlier instruction in the third verse of chapter five that the fendente wants the true edge.

3. This play can also be arrived at by using the roverso fendente as a parry against a mandritto (leading the player into a right-foot forwards stance as in the picture), but this is difficult to do; it's much easier to parry roversi with roversi and vice versa.

4. Or, the player attacks with a roverso fendente, which is parried with the roverso fendente of the text, leading to the crossed hands false edge mandritto fendente as in (2).

5. At present my default interpretation favours two and four, biting the bullet of the false edge fendente.

Folio 18R

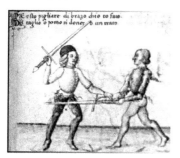

Second play of the sword:

Per sto pigliare di brazo chio to faro
Di taglio o pomo to doner o un trato

By this grip of your arm that I have made,
I can hit you with a cut or pommel strike.

Note that the way the sword blade passes through the word donero, separating doner and o indicates that the text was written after the pictures were drawn.

This play is similar to Fiore's third play of the zogho stretto; when setting this up as a drill you will probably find the original defender best placed to enter on the outside.

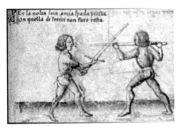

Third play of the sword:

Per la volta fara amia spada presta
Con quella di feriri non faro resta

By this turn that I quickly make to my sword
I will not pause with this strike.

This is a fascinating play, as to all intents and purposes, you end in the same place as you would doing Fiore's Fiore's punta falsa (the 17th play of the master of the zogho largo, crossed at the middle of the swords. From this crossing, Vadi is turning the sword to strike on the outside. The original crossing must have been on the inside, with sufficient pressure from the opponent that his outside line is open. Fiore shows this play done after the master's crossing at the middle of the sword in zogho largo, after which you effectviely feint to draw a wide parry to the opponent's left, opening his outside line. This play is done by a scholar of the second master of the zogho largo, who has beaten an incoming attack wide, so the play follows from there:

Questo zogho si chiama punta falsa o punta curta, e si diro come la fazzo. Io mostro de venire cum grande forza por ferir lo zugadore cum colpo mezano in la testa. E subito chello fa la coverta io fiero la sua spada lizeramente. E subito volto la spada mia de laltra parte piglando la mia spada cum la mane mia mancha quasi al mezo. E la punta gli metto subita in la gola o in lo petto. Ede migliore questo zogo in arme che senza.

This play is called the false thrust or the short thrust. I show that I am coming with great force to strike the player with a middle blow in the head. And immediately that he makes the cover I strike his sword lightly. And immediately turn my sword to the other side, grabbing my sword with my left hand about at the middle. And I place the thrust immediately in the throat or in the chest. And better this play in armour than without. (Trans. mine)

You can see video of my interpretation of Fiore's punta falsa here: http://www.swordschool.com/wiki/index.php/Punta_Falsa

Folio 18V

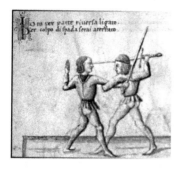

Fourth play of the sword:

Io to per parte riversa ligato.
Per colpo di spada serai aterrato

I have bound you from the roverso side,
You'll be thrown to the ground by a blow
of the sword.

This play is similar to Fiore's 6th, 9th, 14th and 17th plays of the zogho stretto, in which you wrap the player's arms in the ligadura mezana. I can think of no good reason for the player here to have his left arm back in what looks a lot like a classical fencing guard. But the play itself is simple: from the crossing, if he is open on the inside, enter with your left arm under your sword arm and wrap one or both of the player's arms.

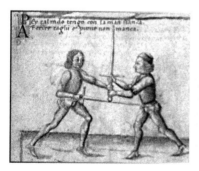

Fifth play of the sword:

Per tal modo tengo con la man stanca
Aferire taglii e punte non manca.

In this way I have you with the left hand,
I will not hold back striking with cuts
and thrusts.

This play is similar to Fiore's 2nd play of the zogho stretto, in which when the player is open on the inside, you reach over and grab the handle of his sword. This works nicely as a variation on the previous play, which you would do from somewhat closer. If you can reach his elbow, do. If not, then grab the hilt.

Folio 19R

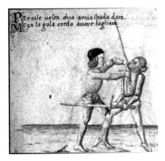

Sixth play of the sword:

Per tale volta chio a mia spada data
Meza la gola credo avere tagliata

By this turn that I have given to my sword I think I will have cut the middle of your throat.

Similar to Fiore's 10th play of the zogho stretto

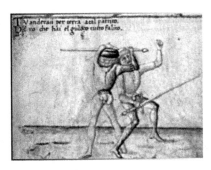

Seventh play of the sword:

Tu anderai per terra a tal partito
Pero che hai el giuoco tutto falito.

You will go to the ground with this technique
And your play has completely failed.

Similar to Fiore's 5th play of the zogho stretto

As on the previous page, these two plays show a very similar situation done at different measures. In the sixth play, you have entered on the outside, stepping behind the player with your right foot, and slam your sword into his neck. To get to the position shown in the seventh play, you enter on the outside with the left foot, with either a pommel strike to the face or an elbow push, and pass again to wrap your right arm round his neck. In terms of footwork, this is exactly how I do the 10th play of Fiore's zogho stretto. This play from Fiore has been variously interpreted, thanks to a disconnect between the text and the image. My reasoning for my interpretation can be found in an article here: http://www.scribd.com/doc/105087800/8910-Stretto and a

video here: http://www.swordschool.com/wiki/index.php/ Stretto_8,9,10

Folio 19V

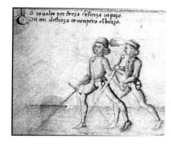

Eighth play of the sword:

Con la mia spada non voglio far guerra
Ma con la tua te mettero in terra.

I do not wish to make war with my sword,
But with your I'll throw you to the ground.

Similar to Fiore's 12th-13th play of the zogho stretto. From the crossing, because your opponent is applying pressure to the bind opening your inside line, you let go of the pommel with your left hand and grab the tip of his sword. You then smash him in the face with his own weapon, which turns him, and can then strike with your sword as you like— or, as here and as in Fiore's 13th zogho stretto play, you can safely drop your sword, grab the handle of his with your right hand, pass in behind him and throw him to the ground.

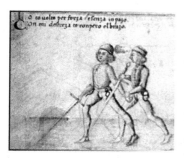

Ninth play of the sword:

Io to volto per forza e senza inpazo
Con mi destreza te ronpero el brazo.

I have turned you with force and without difficulty
With my skill I will break your arm.

No exact correlation to Fiore; using the crossguard to break the elbow as shown here is easy enough when you get his left hand off his sword and the arm extended, but it is a tricky play to set up. Generally, I do it as a defence against the opponent entering to wrap with his left arm,

as in the fourth or fifth play. So, he has opened your inside line, and is reaching over your arms with his left hand. As he does so, intercept his left wrist with your own left hand, stepping out of the way with your right foot, turning the left behind you, and placing your crossguard on his elbow as shown.

Folio 20R

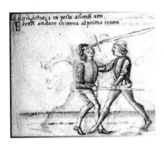

Tenth play of the sword:

Con destreza to posto asimil atto
Faroti andare in terra alprimo tratto

With skill I have placed you in a similar position,
I'll make you go to the ground at the first blow.

The famous "flying sword" play. Note the reference in the text to some other play: perhaps the previous, if my interpretation of it is correct, and quite probably also the fourth. Thanks to the position of the sword, this play appears to have begun with a pommel strike. I set it up in three different ways, none of which perfectly match the image. When one and two are completed we would be in Fiore's 15th play of the zogho stretto, which shows the lock. The sword grab is at the 12th play.

1. From the crossing, the player opens your inside line, and enters to wrap (fourth play). As he does so, I grab the blade of his sword with my left hand, and collect his left elbow with my right. From here I turn to my left, and apply the lock. Note I am still holding my own sword in my right hand, and have not hit him in the face with my pommel.

2. From the crossing, I bind the player's sword over to my left, opening his inside line. I then grab his blade with my left hand, and smash him in the face with the pommel of my sword (using my right hand). Assuming his left arm is conveniently placed for

it, I then drop my sword and scoop up his left arm into the lock. This involves moving to my right, so ending with a different foot position to the one shown.

3. From the crossing, I bind the player's sword over to my left, opening his inside line. I then grab his blade with my left hand, and smash him in the face with the pommel of my sword (using my right hand). I step behind his right foot with my right foot and throw him to the ground. This obviates the arm lock, and I'm still holding my sword. This last is my preferred solution.

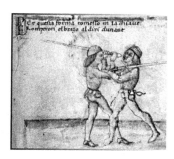

Eleventh play of the sword:

Per questa forma tomesso in la chiave
Eromperoti el brazo al diri dunave

In this way I'll put you in a lock
And break your arm (in the time it takes to) say "hello".

This play has no direct correlation in Fiore, but applies the basic mechanics of a ligadura mezana in a non-standard way. Note that the player is illustrated holding his sword left handed, though I don't think that that affects this play. I get here like so: You are applying sufficient pressure in the crossing to open your inside line, to which the player responds by entering in with a pommel strike. As he enters, use your right elbow to parry the pommel strike by pushing his right wrist to your left, and grab his right elbow with your left hand. Apply force to crank his arm anticlockwise, and down he goes. It looks weird on paper but is smooth and easy when you get the hang of it.

Folio 20V

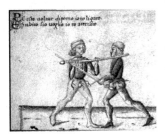

Twelfth play of the sword:

Per sto voltar dipomo io to ligato
Subitio sio voglio io to aterrato

By this turn of the pommel I have bound you,
Immediately If I want to I'll throw you to
the ground.

This play is a variation on the third play (the punta falsa correlate). Note
that the player is illustrated holding his sword left handed, though I don't
think that that affects this play. From the same set-up, you simply enter
a bit deeper, and hook his neck with the tip of your sword. In the image
you are also hooking his blade with your hilt, which gives you a nice
long lever to turn him with. To make the throw as described in the text,
I find it easier to step in behind him with my left foot, which is not
shown in the image. Note that the player is shown left handed.

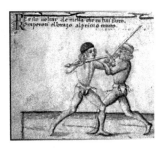

Thirteenth play of the sword:

Per sto voltar de mella che tu hai fatto
Romperoti el brazo alprimo tratto.

By this turn of the blade that you have done,
I will break your arm at the first attempt.

This play appears to be a counter to the play above (though the one
doing it is clearly not left-handed). As he enters to hook his blade over
your neck, you push it aside to your right, which exposes his left elbow.
Hook your handle over his left arm, and bear down and forwards as if
striking a mandritto fendente. There is no exact correlation in Fiore.

This play is probably the one referred to in chapter XV above.

Folio 21R

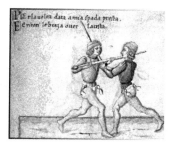

Fourteenth play of the sword:

Per la volta data a mia spada presta
Feriroti le braza over la testa

By the quick turn I have given my sword,
I'll strike your arm or your head.

As illustrated, this play would result in injury to both combatants. From the context, and the text, I think that this is a counter to the punta falsa-type plays (three and twelve) we have seen before. As the player makes a turn to his sword, to enter with the punta falsa, you turn your sword inside his turn, to strike. Fiore would have us finish with the same half-sword grip that the punta falsa employs, but Vadi doesn't appear to do so. They have in common the fact that the strike is made from inside the loop made by the attacker's arms and sword. For reference's sake, here is Fiore's text:

Questo sie lo contrario del zogho che me denanzi, zoe de punta falsa overo di punta curta. E questo contrario si fa por tal modo. Quando lo scolaro fieri in la mia spada, in la volta chello da a la sua spada, Subito io do volta ala mia por quello modo che lui da volta ala sua. Salvo che io passo ala traversa por trovar lo compagno piu discoverto. E si gli metto la punta in lo volto. E questo contrario e bona in arme e senza.

"This is the counter to the play that is before me, so the false thrust or the short thrust. And this play is done in this way. When the scholar strikes my sword, in the turn that he makes to his sword, immediately I make a turn to mine, in the same way that he made a turn to his. Except that I pass across to find the companion more uncovered. And then I place the thrust in his face. And this counter is good both in armour and without." (Trans. mine)

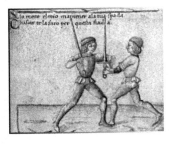

Fifteenth play of the sword:

Sio metto el mio mantener ala tua spada
Chascar te la faro per questa fiada.

If I put my hilt to your sword
I'll make it fall with this action.

This is exactly like the 19th and 20th plays of Fiore's zogho stretto, the soprana tor di spada (upper taking of the sword, i.e. disarm). There, from the zogho stretto crossing, Fiore has us enter on the outside, reach over the player's arms with our own left arm, and using the handle of our sword against the flat of the player's blade, drive the player's sword around in a big clockwise circle, stripping it from his hands. Vadi mentions but does not show this use of the handle to drive the player's blade. Note that he describes his 19th play as *un tor di spada che soprano*, which is a fair description of what's happening (a disarm from above), but is mechanically completely different to this play.

Folio 21V

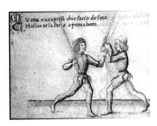

Sixteenth play of the sword:

Questa e una presa chio facio de sota[2]
Chascar te la faro a prima botta

This is a grip that I do from below,
I will make it fall at the first go.

This is an odd play, as the grip is shown with your left hand grasping the player's left wrist. This does almost nothing to control his sword.

2 Mele and Porzio have mis-transcribed the last word of the first line as fora, not sota, which would be "outside". Fora does not rhyme with botta, and the play is illustrated on the inside, not the outside, so I am confident that this is an error.)

Given this play's placement after the prior disarm, and the "make it fall" in the text, it seems likely to me that this is supposed to be some variant on the sottana tor di spada (Fiore's 22nd play of the zogho stretto). But from the position shown in the image (if I ended up there by accident – I wouldn't go there deliberately!) I would prefer to simply push his sword away to my left and strike.

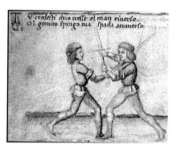

Seventeenth play of the sword:

Tu credesti chio tresse el man riverso
Col gomito spingo tua spada atraverso

You believed I would strike with a backhand blow,
With the elbow I push your sword across.

This is unlike any of Fiore's plays. There is no clear winner in the image, but the player on the right may be keeping the other sword away with his right elbow. Perhaps from the crossing, assuming sufficient pressure from the player to open his outside line, you lift your sword to the other side of the player's sword, which would look like you're about to strike a roverso. Place your right elbow on his blade to keep him from parrying, pushing it further to your right. Then, I imagine, strike.

Folio 22R

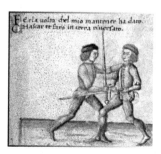

Eighteenth play of the sword:

Ferla volta chel mio mantener ha dato
Chascar te faro in terra riversato.

Making the turn that my handle has given,
I make you fall to the ground backwards.

This may be related to Fiore's 14th of the second master of the zogho

largo, or perhaps the ninth of the sword in one hand. In any case, I do it like so: from the crossing, the player exerts enough pressure to open his outside line. I yield and enter as usual, hooking (in this case) his blade with my handle, and passing my left foot in behind his right. My left hand goes to his neck, and I throw, pulling with my right hand and pushing with my left (much like in the first play of Fiore's third master of the dagger, incidentally).

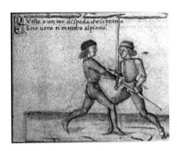

Nineteenth play of the sword:

Qvesto e un tor di spada che soprano
Eseio voro ti mettero alpiano.

This is a disarm that is above,
And if I want to I'll lay you flat.

This is unlike any of Fiore's plays, though the term *tor di spada* is one Fiore uses for four different ways of disarming the player, all of which use the same basic motion, just a different way of gripping. Instead of the clockwise turn that Fiore uses (and Vadi also at the 15th play), here we enter from the inside. From the usual crossing, with the player's inside line open, grab his blade with your left hand, hook over his right wrist with the hilt of your sword, and pull. This exerts a nasty lock on the player, and yes, you can easily bring him to the ground.

Folio 22V

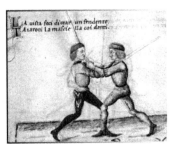

Twentieth play of the sword:

La vista feri di trar un fendente
Taiaroti la masciella coi denti.

The feint that I made to strike a fendente,
Cuts the jaw and teeth together.

This play is not in Fiore. This is a clear and unambiguous use of the feint; the real strike is on the outside, and done very near the hilt. Clearly then the feint had to go on the inside line, to draw the opening. I set this up from the crossing by starting with his inside line open, and feinting with a thrust to his face. As the player pushes my thrust aside I turn it and strike, passing in with the left foot as shown.

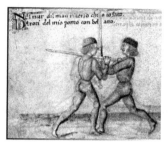

Twenty-first play of the sword:

Nel trar dil manriverso chio to fato
Daroti del mio pomo con bel atto.

From the backhand strike that I have done,
I'll give you a good strike with my pommel.

The player on the right appears to be striking with the pommel on the other player's inside line. This squares nicely with the text. A roverso (on the outside) draws a parry from the player, to which you yield, enter and strike with the pommel in the inside. It can easily be done as a follow-on to the previous play.

Folio 23R

Note that the bleed-through on this page suggests that these pages are not in the correct order. It appears that the pollax guards (now labelled on 24R) should really be here at 23V. We can clearly see them behind the players. This needs investigation by a trained palaeographer.

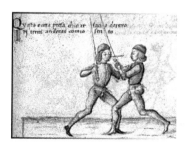

Twenty second play of the sword:

Questa e una presa chio te facio dentro
In terra anderai comio sento.

This is a grip that I do on the inside,
I feel that you're going to the ground.

This is very much like Fiore's 17th play of the zogho stretto, and others. As shown, you reach in with your left hand and grab the player's right elbow. This can be done most easily if the player, open on the inside, lifts his hands (as he might if threatened by, for example, a thrust). Then reach in, between his arms, find his elbow and wrap. It works in the same way as a ligadura mezana.

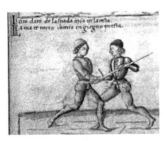

Twenty third play of the sword:

Ioto dato de la spada mia in la testa
La tua te torro comio ingiegno presta.

I have given you my sword in the head,
Yours I'll take with my quick cunning.

This is like Fiore's 23rd play of the zogho stretto, which is one of the disarms, done by grabbing the player's sword by pommel and blade, and turning it. The difference here is that this is done on the inside, and so the turn is in the other direction. It's quite simple: from the crossing, with his inside line open, grab his blade with your left hand, smash him in the face with your sword, then let go of it and grab his pommel with your freed right hand. Turn his sword anti-clockwise to disarm.

Folio 23V

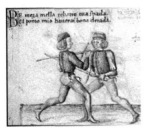

Twenty fourth play of the sword:

De meza mella rebatto tua spada
Del pomo mio haverai bona derada.

I beat your sword aside with the middle of the blade,
You'll get a good deal from my pommel.

This play has no exact correlation in Fiore, but is would be easy enough to do if the text matched the pictures better. The image is quite straightforward: from the same blade grab done on the inside line as in the previous play (and others) simply pommel strike to the face. This is perhaps the mid-point of the previous technique. But the text demands that we beat aside his blade with the middle of ours. Again, very straightforward, but does not easily lead to the image shown. Perhaps from the crossing, we push or beat the sword aside to our left, leaving him open on the inside to our entry with the pommel.

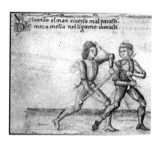

Twenty fifth play of the sword:

Voltando el man riverso mal parasti,
De meza mella nel ligame intrasti

Turning a roverso you parried badly,
Entering into a bind at the middle of the blade.

This last play is a little ambiguous: who turned the roverso which you parried badly? Do I, and as you parry I do the play? Or is the roverso your parry which is about to fail?

One possible reading of the image is that the player on the left has, from the usual crossing, entered with a punta-falsa type action. This can easily be described as turning a roverso, as the action comes from your backhand side. The player on the right (who is confusingly illustrated left-handed, though I don't think this is a left-handed play as such) has been pushed around by the other's entry, and is about to be thrown.

Another possibility is that I enter with a roverso, which you parry from a right side guard The blades meet middle to middle as usual, but I allow my point to be beaten aside, and use that energy to enter in on your outside, turning my sword and grabbing the blade with my left hand as shown.

Note that these last two plays both emphasise the middle of the sword (*meza mella*).

PLAYS OF THE POLLAX

VADI INCLUDES ONLY four guards of the axe and only four plays. (Fiore has six and ten.) It feels as if he includes the axe for the sake of completeness, but is not hugely interested in it. For anyone versed in Fiore's armoured combat material, there is nothing new or different here. Indeed, the first pairing of guards we see could be taken straight out of *Il Fior di Battaglia*.

Folio 24R

GUARDIE DAZA IN ARME.

Guards of the Axe in Armour.

Son posta di dona de grande offesa.
Per respondere a ciaschaduna inpresa

So in posta di cingiaro con il dir sona
Te guastaro per certo tua persona.

I am the guard of the woman, of great offence,

I am in the guard of the boar, with its saying,

To respond to any situation.

I'll destroy your body for sure.

This pairing of axe guards is found in Fiore, with almost identical images. Fiore's text reads:

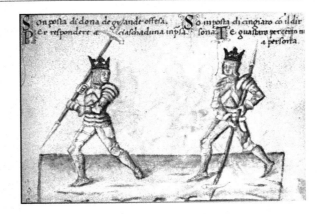

Posta di donna son contra dente zengiaro. Si ello mi aspetta uno grande colpo gli voglio fare, zoe che passaro lo pe stancho acressando fora de strada, e mostraro in lo fendente por la testa. Esi ello vene cum foza sotto la mia azza cum la sua, se non gli posso ferire la testa, ello no me mancha a ferirlo o in li brazzi o en le man.

I am the Woman's guard, and I am against Boar's Tooth. If he expects the great blow that I want to do, I will pass, with my left foot stepping out of the way, and show him the fendente to the head. And if he comes with force under my axe with his, if I can't strike his head, I will not fail to strike his arms or his hands.

Si posta di donna a mi porta di ferro mezana e contraria, io cognosco lo suo zogo ello mio. E piu e piu volte semo stade ale bataglee cum spada e cum azza. Esi digo che quello chella lo po far a mi. Anchora digo che se io avesse spada e non aza che una punta gli metteria in la fazza, zoe, che in lo trar che posta di donna fa cum lo fendente, e io son in porta ddi ferro mezana a doi mane cum la spada, che subito in lo suo venire, io acresco e passo fora de strada, sotto la sua azza per forza io entro. E subito cum la mia man stancha piglio mia spada al mezo ela punta gli metto in volto. Si che tra noy altro che de malicia e pocha separacione.

If the Woman's Guard opposes me, the middle Iron Gate, I know her play and mine. And many times we have stood to fight, with sword and with axe. And I'll tell you what she can do to me. Also I'll tell you that

if I had a sword and not an axe I'd put a thrust in her face, so, in the strike that the woman's guard makes with the fendente, and I'm in the middle iron gate with two hands on the sword, immediately in her coming, I step and pass out of the way, under her axe with force I enter. And immediately with my left hand I grab my sword by the middle and I place a thrust in the face. There is nothing but malice, and little difference, between us.

Note that in the text for posta di donna, the opposing guard is called boar's tooth; in the text above boar's tooth, the guard is called the middle iron gate. Given that it is held on the left side with the shaft under the arm, I think of it (as Vadi also clearly does) as boar's tooth. Note also that the text is referring to the sword, not the axe, though of course you would probably do exactly the same thing with either weapon.

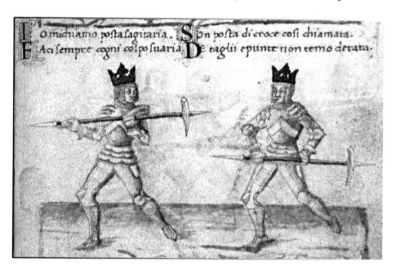

Io michiamo posta sagitaria
Faci sempre cogni colpo suaria

Son posta di croce cosi chiamata.
De taglii epunte non temo derata.

I am called the Archer's guard,
I always make blows deviate.

I am the guard of the cross, so called,
No cuts or thrusts can bother me.

So, the archer's guard defends well against all blows. Recall that with

the longsword it is used to defend against a rota, in chapter XV. The guard of the cross is held just like Fiore's *vera croce*; the archer's guard is different, but the pairing in Fiore is with *breve la serpentina*, which is similar to *sagitaria* in that the weapon is on the right side, you're left foot forwards, but *breve la serpentina* is held forward weighted and with the hands down.

Folio 24V

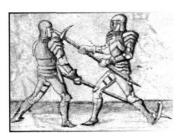

First play of the axe:

Io era in dente de cinghial con laza
Per questo io to ferito nela facia

I was in boar's tooth with the axe,
In this way I have struck you in the face.

This is exactly in keeping with Fiore's use of zenghiaro as described above; Fiore does not illustrate this play exactly, though his third play of the axe is similar.

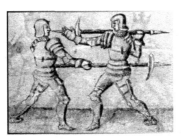

Second play of the axe:

Levata la visera io to nel volto
Io to ferito ogni difesa otolto

Lifting the visor I strike your face,
I struck you: all defences are gone.

This is much like Fiore's fourth play of the axe, though following on from a cover on the other side so the player's position is different. Note that though the text clearly refers to raising the visor to strike the face, there is no visor illustrated.

Folio 26V

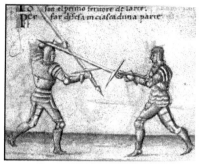
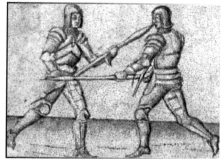

Io son el primo feritore de larte
Per far difesa in ciascaduna parte

I am the first wounder of the art,
To make defence on any side.

I spingo al volto tuo la mia punta
Tv vedi de mia spada ognor piu monta

I push my point into your face,
You see my sword rising up and up.

Together these two plays are practically identical to Fiore's first two plays of the sword in armour. As the player attacks, you parry between your hands, from left to right, passing in and thrusting to the face. You can see the similarity in this excerpt from the Novati MS, carta 25B.

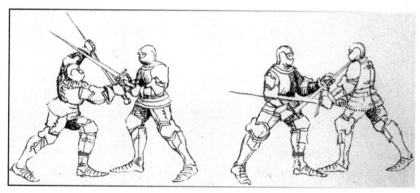

Folio 27R

LA spada uo che lasci altuo dispetto

FA roti pegio ancor per tuo difeto

You will let go of your sword in spite of your wishes,
I will do even worse to you too.

This appears to be the same as Fiore's 14th play of the sword in armour.

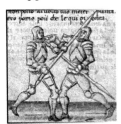

Se non posso al volto tuo meter punta.

Metero pomo poii che le qui gionta.

If I can't stick a point in your face,
I'll stick a pommel instead, as it is there.

This is very like Fiore's tenth play of the sword in armour. Note that the player on the right is winning (according to the text); his armour negates the blade against his neck.

Folio 28R

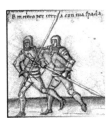

PErlo passare mio for de strada.

TE metero per terra con tua spada.

By the pass I have made out of the way,
I'll throw you to the ground with your sword.

This appears to be Fiore's seventh play of the sword in armour, done from the other side (so, right foot forward and with the pommel, rather than left foot forward and with the point).

Here end the blows of the spear,
They usually go to this technique.

"This technique" is identical to the one and only spear remedy that
Fiore shows. Beat the attack aside and strike, from any one of the three
prior guards. Fiore's advice regarding how to do it might be useful here:

From the text above *tutta porta di ferro*, folio 39R:

> ...*Zoe che passaro cum lo pe dritto ala traversa*
> *fora de strada, e traversando la sua lanza*
> *rebattero in parte stancha. E si chello passar ello*
> *rebatter se fa in un passo cum lo ferire, questa e*
> *chosa che non se po fallire.*

So, I pass with the right foot diagonally
out of the way, and crossing his lance I
beat it to the left side. And if the pass and
the beating are done in one pass with the
strike, this is a thing that cannot fail.

PLAYS OF THE DAGGER

HERE, WITHOUT INTRODUCTION, masters in guard, or preamble, Vadi presents a mish-mash of dagger plays, with no readily apparent organisation. I suspect a missing page, or a mix-up in the rebinding of the manuscript at some point. It seems likely though, having gone through them in detail, that they are grouped by the original defensive action, as are Fiore's dagger plays. But this is not specified anywhere. To make life easier for the reader I have identified five groups of plays, and have split up the material accordingly, without changing the order of the plays as they are currently bound.

If you are unfamiliar with Fiore's dagger techniques, I suggest reading my *Mastering the Art of Arms vol 1: the Medieval Dagger*, before embarking on this chapter.

GROUP ONE: AN APPARENTLY RANDOM PAIR OF PLAYS.

Folio 29R

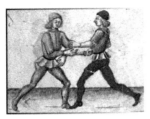

Qvesto contrario che io te facio.

Si per voltarti la presa dil bracio.

I do this counter to you,

Turning you with the grip on your arm.

Here the defender has covered with his arms crossed, and the attacker pushes with his left hand the defender's left elbow. This is very similar to the counter-remedy shown by Fiore against the cover of eighth master, done arms crossed. The fact that the very first play shown is a counter-remedy is a clear indication that this manuscript is either missing pages or has been woefully shuffled at some point in the past.

Per la man che tu hai sopra laspalla

Tv anderai i terra in ora malla.

With the hand that you have on my shoulder,

You'll go to the ground in a bad hour

(i.e. you will suffer greatly!)

This is exactly like Fiore's second play of *abrazare*; there is no dagger illustrated here. There's no question that these two plays have always been on the same page, but I can't for the life of me figure out why. The bleed through on this page suggests that the recto-verso descriptions here are wrong. 29V does not appear to have bled through to 29R, though the shadows may be an imprint of the spear play on 28V.

GROUP TWO: DEFENDING WITH THE DAGGER.

Both players have daggers. This group deals with defending with the dagger against an attack. The first four plays follow from the same basic cover, holding the dagger by grip and point, parrying with the blade against an overhand blow, and then doing one of the actions that follow. This is as Fiore's sixth remedy master. Then there is the cover done with the arms crossed, as in Fiore's seventh master, and then an original (as far as I know) dagger defence, sweeping the attack away from left to right, holding the dagger in both hands. As the attack has now changed to a low blow, I'll split this off into the next group.

Folio 29V

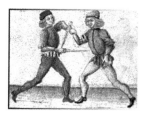

La daga tor te posso e ferire
In questa presa enon pora falire.

I can take the dagger and strike you
With this grip, and I cannot fail.

This is exactly the same as Fiore's second and fifth plays of the sixth master, which makes sense given the following plays that show a similar cover to the sixth master.

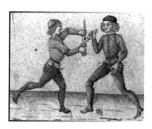

La daga in terra ti faro cadere.
Con la volta chio faro e col sapere.

With the dagger on the ground I'll make you fall
With the turn that I do, and with my knowledge.

This is like the cover of the sixth master, which can indeed lead to disarms and takedowns. Assuming this continues as in Fiore, the scholar on the left would roll his point over the player's arm while turning to the right, using

the contact between the daggers to strip the weapon out of the player's hand.

Folio 30R

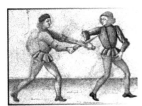

Questa punta sie subito fatata
Faro cadere la daga molto ratta.

This thrust is done immediately
I make your dagger fall very fast.

This is exactly like the third play of the sixth master

Qvesta ponta in la man to metuta
Tosto la daga te sera caduta.

This thrust that I have placed in your hand,
Quickly you will drop your dagger.

This is exactly as the eighth play of the sixth master. As the attacker comes in, you stab him in the hand.

Folio 30V

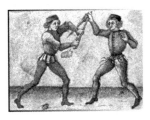

Qvesta coverta io faro ben tosto
Che tu serai in la chiave posto.

This cover I make very quickly,
So you will be placed in the lock.

This is exactly as Fiore's seventh dagger remedy master. Fiore makes it clear that even though the illustrations don't show armour, you should only make crossed-arm defences in armour, as they are short, allowing the attack to get very close, but strong, as they use both arms.

GROUP THREE: DEFENCE WITH THE DAGGER AGAINST A LOW BLOW.

The plays that follow do not necessarily (or even probably) follow from the cover shown on 30V: there the defender is clearly getting to the outside, but the plays that follow are done on the inside, or at least appear to be in the illustrations. The attack is the same in each case.

Folio 30V (cont)

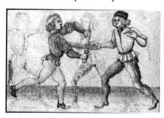

Aun gioco saltaro permia coverta
E con mia daga faro lavia aperta.

I will leap to a play using this cover,
And with my dagger I'll open the way.

This cover has no exact parallel in Fiore; it sweeps the attack from left to right. The scholar's dainty red shoes and mincing leap caused much merriment in class when we went through this play.

Folio 31R

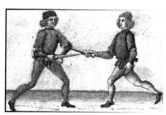

Per questa coverta che tu voi fare
In la chiave disoto to faro intrare.

With this cover that you want to do,
I'll make you go into the lower lock.

This is an odd illustration, as it's not clear who is doing what. The man on the left is probably covering the attack with his left arm; how the attacker capitalises on that is unclear. In Fiore, the *defender* would place the attacker in the lower lock from here.

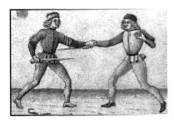

Si posso tor la daga ancho ferire.
Se larte non voro intuto falire.

I can take the dagger or strike,
If I don't want to completely fail the art.

This is like the ninth play of the ninth master of the dagger in Fiore; from here you can disarm or strike. You can get her either from a two-handed cover with the dagger, then switch your left hand to his wrist, or you can go directly to cover with your left hand while striking with your dagger.

Folio 31V

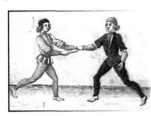

SIo carco la daga verso terra
Con quella non me farai piu guerra

If I push the dagger towards the ground,
You will make no more war with it to me.

This is just like the second and tenth plays of the ninth master from Fiore, and plausibly follow from the previous technique. Note that the defender is unarmed, and grabs the attacker's wrist with his left hand and dagger blade with his right hand.

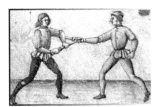

Qui cerco la tua man perlei feri...
Sotto la chiave te faro veniri

Here I look for your hand to strike it
I'll make you come under the lock.

(Note the last letters are missing from the first line. To complete the sentence, making sense, and to rhyme with the next line, I complete the word as "feriri")

Here the defender is striking the attacker's hand and from there going in to wrap him up. Striking the attacker's hand has already been shown against a descending blow on 30R. From here you wrap his right arm up from underneath with your left arm, and (I imagine) keep on stabbing him.

Folio 32R

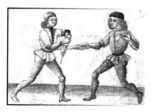

Qvesto in crociare che verso te i facio
Te mettero in la chiave con inpaccio.

This crossing that I make against you
I'll place you in the lock without difficulty.

This is a variant not found in Fiore, where the dagger held doubled and crossed is used to sweep a low blow to the left. This would lead to striking overhand with the dagger (it's held in an ice-pick grip), unlike the preceding plays.

GROUP FOUR: UNARMED DEFENCE AGAINST AN OVERHAND BLOW.

These plays, or variants of them, are all found in Fiore's first master of the dagger.

Folio 32R

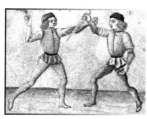

Qvesto ferire con lo pugno faccio.
La daga tua nel corpo te caccio.

This strike I make with the fist,
I'll stick your dagger into your body.

This is exactly like Fiore's eighth play of the first master, covering to the outside. The scholar intercepts the descending blow, stepping offline to the left, and drives the blade into the attacker's belly or thigh.

Folio 32V

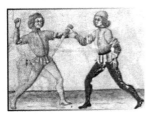

I Facio la coperta duna mano
Faro che tua daga andera al piano.

I make the cover of one hand,
I make your dagger go to the ground.

This is exactly as Fiore's first play of the first master.

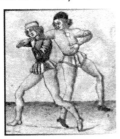

Per lo modo chio to preso non dubito
Tv anderai in terra dico subito.

From the way I have grabbed you I do not doubt
That you'll go to the ground, I say immediately!

This is a variant on Fiore's seventh play of the first master. Here we grab his throat instead of wrap an arm round his neck.

Folio 33R

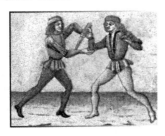

Al modo chio to tengo so disposto.
Rompere el bracio e la daga piu tosto.

By the way that I have got you
I'll break the arm and the dagger very quickly.

This is exactly as Fiore's 5th play of the first master.

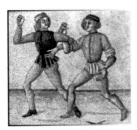

Tv vedi bene a modo chio te tegno.
CHe tu e tua daga sera mio pegno.

You see well the way that I have you,
So you and your dagger will be my pawn.

This is just like Fiore's 3rd play of the first master, the ligadura mezana or middle lock. "Pegno" is literally pawn (as in chess), but also pledge or forfeit. The sense here is that the player is firmly under your control.

Folio 33V

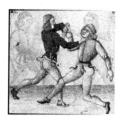

Io vedo questo gioco non me falla.
CHio rompa el bracio sopra la mia spalla.

I see that this play will not fail me.
As I break you arm over my shoulder.

This is just like Fiore's 16th play of the first master.

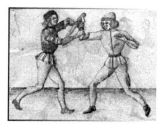

Per questo modo el bracio uo pigliare
Per quella daga te faro serrare

Because of this way that the arm is grabbed,
I will lock you with this dagger.

This is a counter perhaps to the first play on 33R, though is missing the left hand on the dagger that would make it like Fiore's 6th play of the 1st master, where he grabs the dagger by the blade and drives it into the defender's right elbow. I think it likely that the attacker is redirecting his point into the defender's right elbow, hence "locking" him with the dagger.

Folio 34R

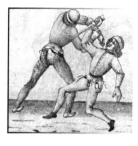

VE di che sei astretto e interra vai.
Rompo el bracio ela daga perderai.

I saw that you are bound and going to the ground,
I break the arm and you'll lose the dagger.

This lock has your left forearm blocking the attacker's right wrist, and you reach up and under his right elbow to grab your own left wrist, applying a crank to break the arm or throw. This is exactly as Fiore's third play of the second master, and it can also be done from the cover shown below it.

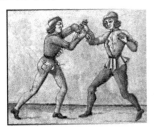

AQuesto modo tengo e facio carco.
E Posso poi sequiri el streto e largo.

In this way I have you, and I make a burden,
And I can then follow the close and wide.

This play is just as Fiore's 14th play of the first master, called "piu forteza", more strength. The defender's left wrist is gripped in his right hand, and is used to oppose the dagger attack from above. Vadi's "facio carco" seems to mean "I'll give you trouble" or something similar, and he continues by saying that he can follow with close plays or wide plays. The essential difference between these is that the weapon is constrained or not; it appears that Vadi is using these terms here to indicate either stripping the dagger and striking (wide play) or applying locks or throws (close play).

GROUP FIVE: UNARMED DEFENCE TO THE OUTSIDE, AGAINST A FENDENTE OR ROVERSO ATTACK.

This section appears to conflate the second and third of Fiore's dagger remedy masters.

Folio 34V

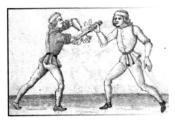

Io vengo ate con le braci in crociate.
Eposso far tuti i giochi passati.

I come at you with crossed arms,
And I can do all the previous plays.

This cover with the crossed arms is exactly as Fiore's second master, who does this cover in armour. From here you can do any of the previous plays.

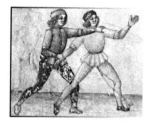

AN ndarai interra per man riversa.
PE r questo gioco avrai la vita persa.

You'll go to the ground by the backhand,
By this play your life is lost.

This is very similar to Fiore's third master cover and takedown in the Getty MS (not the Pisani Dossi), though he is targeting the left shoulder, not the face. It could be intended as a forearm smash to the throat though, which would probably work better, and fit with the text of the first line, which suggests that it's a backhand blow that sends the player to the ground.

Folio 35R

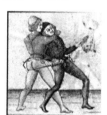

TV sei nelarte dico asai mal dotto.
TE trovarai interra qui de botto.

I say you are badly taught in this art;
You will find yourself suddenly on the ground.

"De botto" is "suddenly" but also "with a thump" – very apt!

This play is exactly as Fiore's second play of the third master in the Getty. Having covered to the outside, you shoot in for the neck with your right arm.

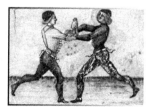

Per questa presa io disse co io tave.
Io son cierto che intrarari inla chiave.

By this grip I say I have you,
I am certain you will go into the lock.

From the image it isn't clear whether the defender (on right) is acquiring the attacker's wrist and elbow and is about to do the following play, a classic arm break with the hands low, the attacker's arm at waist height; or whether the attacker is about to do one of the hand traps using the dagger (such as Fiore's seventh play of the third master, or ninth play of the first master). The text suggests the former.

Folio 35V

Io faro un carco acquesto tuo cubbito.
Romperoti el bracio senza dubbito.

I make a lock to this, your elbow;
I'll break your arm for you without doubt.

Here we have "faro carco" again, literally "make a burden". This play is exactly as Fiore's third and fourth plays of the third master. Having intercepted his wrist with your right hand and his elbow with your left, you crank his arm clockwise.

Qv esto e un guastar di bracio molto forte.
EL dolor ,che tu hai mal el comporte.

This is a very strong destruction of the arm,
The pain that you'll have will ruin your composure.

This play is a variant on the one before, and bears some similarity to the fifth play of the third master: not least as Fiore also mentions the pain that the player will experience. In this technique you twist the arm clockwise, and dislocate the shoulder (sometimes the elbow).

Folio 36R

Io to messo in la chiave al tuo dispeto.
Per che non sei nelarte si perfeto.

I have put you in the lock, to your despite,
Because you are not perfect in the Art.

This is exactly as Fiore's sixth play of the third master; the classic one-armed lower lock.

CO la man drita o fato cotal mossa
TE faro ficar la daga nela cossa.

With my right hand I have made this move;
I will stick the dagger in your thigh.

Note: this is much like Vadi's own play on folio 32R, bottom pair. The grip is different, done with a left hand grip on the attacker's right wrist, and the right hand on the pommel of the dagger.

Folio 36V

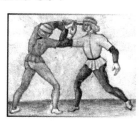

QV uando in terra serai tu porai dire
I O non credea gia cosi venire.

When you're on the ground you'll say,
"I didn't believe it would come to this".

This play doesn't work if done exactly as the image, because it is a crank on wrist and elbow, but lacking any contact point with the wrist. As the text says, I don't believe it! The defender's left hand is behind the attacker's right wrist, gripping the defender's own right wrist, which is in front of the attacker's right elbow. For some reason the dagger is pointing backwards. There is no parallel in Fiore, though this is probably meant to be like the third play of the second master, or the twelfth play of the first master

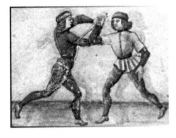

Qvesto e un metere interra che assai forte:
Volendo io tu poi ricevere morte.

This is a strong way to throw someone to
the ground;
If I wish it, you will die.

This is just like Fiore's second play of the fourth master. It is indeed a
very strong crank, which breaks the arm and throws the player to the
ground.

Folio 37R

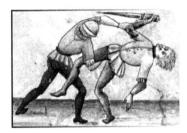

I O te tengo in modo al mio parere
I N terra anderai contra el tuo volere.

I have you, by the way that I parried;
You will go to the ground against your
wishes.

This is exactly as Fiore's 20th play of the first master, and indeed the
fourth play of the fourth master, so we have several ways to get into it.

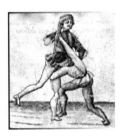

EL ti bixogna puro andar in terra
E con la dagaga non farai pui guerra.

You must just go to the ground,
And you'll make no more war with the dagger.

This play has a cover with the right hand against the attacker's right
wrist, and the left arm through his legs to do a crotch-lifting throw. Given
the position of the attacker's left hand, which may be holding the
defender's jacket, this may be as the seventh play of the fifth master.

Folio 37V

Per lo passare fato soto el bracio.
IN terra te poro con molto inpacio.

By the pass that I do under the arm,
You'll go to the ground with much trouble.

This is either a counter to the previous play, as suggested by the way the man on the right has hold of the other player's arm, and which is over his shoulder; but the image suggests that the man in the right is more likely to be winning. It seems to me most like a counter to the over the shoulder arm break on folio 33V, which would be paralleled in Fiore's 17th play of the first master (a counter-remedy to the 16th play). But again the text implies that the one under the arm is the actor: perhaps he is about to step away twisting the arm, and execute a lock or break.

MESURA DE DAGA

LA longeza de la daga volesere fina al gomito con untaglio e dui cantoni el manico vol esser duno somesso como apare la forma dessa dopenta qui disotto.

The Measure of the Dagger

The length of the dagger should be just to the elbow, with an edge and two corners. The grip should be the length of the fist, as the shape is shown depicted here below.

The term *sommesso* is not in modern usage, but is defined in the Vocabolario degli Accademici della Crusca as "la lunghezza del pugno" (the length of a fist). Florio has it as "a hand-breadth".

This is a long rondel dagger, with a thick back edge (hence the two corners).

PLAYS OF UNEQUAL WEAPONS

ONE OF THE pleasures of reading a medieval combat manual is the range of situations they sometimes include. My favourite bit in Paulus Kal, for example, is where we see a man with a club standing in a waist-deep hole with his female challenger swinging a rock in a veil at him. I have a similar affection for this section.

Folio 38R

Io mi defendo puro quanto io poso
Como tu traii io te vero adoso

I defend myself just as well as I can,
As you strike I will overcome you.

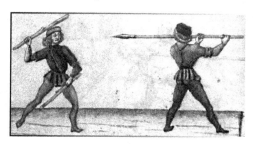

This situation, of a man waiting with two tree branches against a man with a spear is shown in Fiore – though Fiore gives the defender a dagger

too. In that play, which comes between the longsword zogho stretto section and the beginning of the armoured combat, the branch in the right hand is thrown at the spearman's head, his attack parried with the branch in the left hand, and the defender strikes the spearman in the chest with the dagger, passing forwards. I assume that Vadi would have us do similarly; at least parry with the left hand branch, and strike with the right.

Como tu lance el colpo sera perso.
REbatero tua arma col riverso.

As you throw, your blow will be lost;
I'll beat away your weapon with a backhand blow.

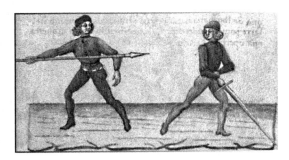

This position looks much like the set-up for Fiore's sword in one hand plays, though this scholar does appear to be holding the sword in two. The sword is held on the left and pointing down and back. The player's spear is held to throw. In Fiore, the master of the sword in one hand faces three players (cut, thrust and thrown sword); the sword against the spear is show after the *zogho stretto*, and the scholar is in *dente di zenghiaro*. So, this is not a direct copy, but a conflation of the two plays. Fiore specifies defensive footwork – step your front foot offline and pass across. I do this only and always to the right, which is mechanically strong and avoids decision-making, which slows reaction time.

Folio 38V

Io sono in guardia col bon man dirito.
Io me tu lance intenderaii lo scrito.

I am in guard with a good forehand blow,
As you throw at me you'll understand the text.

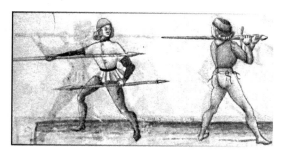

This set-up has the scholar in fenestra on the right, waiting for the player to throw his lance. The player holds two lances. This exact set-up does not appear in Fiore, but it is not hard to guess what happens next: the player throws, the scholar beats the weapon aside while passing offline, and strikes.

SE guitando lopra precede alcuni partiti de daga como seguita: bixogna considerare lato la presa el principio el finire per volere intendere el modo: avixo e quanto sia lingiegno de lhumana natura e pero ognuno che sia pratico nel larte pora intendere tutti gliatti dopinti eposti inquesta mi opereta: E prima de spada aza lanza e daga:

Following the work are some dagger techniques as follows. You must consider the act, the grip, the principle and the finish to understand the way. Knowing how cunning human nature is, and for everyone who is practiced in the art can understand all the actions depicted and shown in this, my little work, mainly of the sword, the axe, the spear and the dagger.

I am tempted to rewrite this thus:

As an appendix to this book, here are some dagger techniques. To be able to do these things you must know the action: the grip, the principle, and the finish. (So, the grapple that it's based on, the principle of what you are trying to do, and how the action is supposed to end). Human nature is cunning, and anyone who knows this art well should be able to do any of the techniques I show in this little book of mine, which covers the sword, axe, spear, and dagger.

But as my patrons expressed a preference for a more literal translation, I shan't!

ADDITIONAL PLAYS
OF THE DAGGER

THIS EFFECTIVELY CONCLUDES Vadi's book, but for some reason he has thrown in eight additional plays, each taking up two images, with absolutely no description. The text in each case is the same. With the first image he writes *Partito di daga* (Dagger technique), and with the second image *Finire del partito* (End of the technique). Helpful, isn't it? I have explained the actions as I interpret them so that the reader can have some idea what is likely to be going on. I shan't include the original text with the images as it adds nothing.

Folio 39R

This technique appears to be a defence against someone grabbing you in a headlock and murdering you with his dagger. The defence appears to be "stand up". Though the appearance of the defender's right hand on the attacker's right hip in the first image suggests that you may by pulling the hip to turn him away from you.

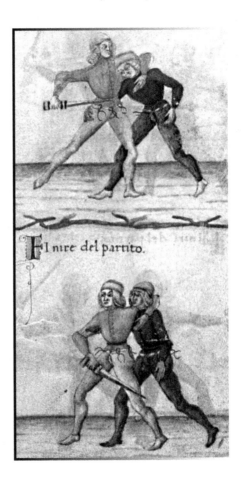

Folio 39V

This is a defence against being grabbed from behind, while you are waving a dagger in the air. Note also the mystery grip change on the part of the attacker – he goes from holding it in a forward grip to reverse grip as you move. Anyway, as he grabs you, turn to your left. This gets you away from his weapon and allows you to deploy yours.

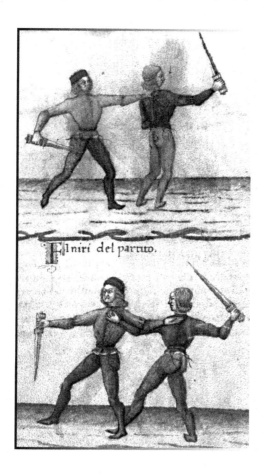

Folio 40R

When grabbed by a man holding a dagger (as in Fiore's fifth master plays) while you are armed with a sword in a scabbard, held in the left hand (as in Fiore's plays of defences of the sword against the dagger), you draw the sword and cut over his right wrist to stop his attack (and presumably damage his arm). It's likely that this is done while stepping back to make room for your longer weapon. Note that the first capital is incorrect; the P is rendered as an F, with comic results for English speakers.

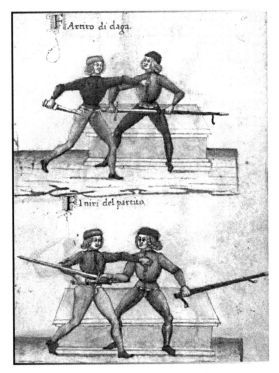

Folio 40V

This is a fantastically unlikely play: your dagger hand is gripped from around the back of your neck by your opponent's left arm. I am assuming an illustrator error here – the attacker's arm should be in front of you, not behind your neck. Anyway, you grab his left wrist with your left hand and turn him to strike. If the illustrations are accurate, you also shift grip here, which is unlikely.

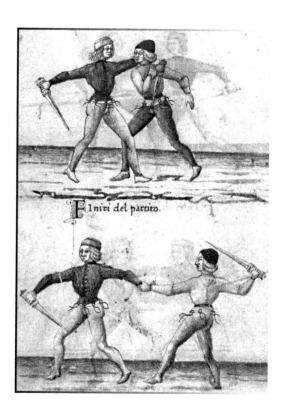

Folio 41R

This is another variant on the fifth master of the dagger, where as he grabs your jacket, you move in for a hip throw.

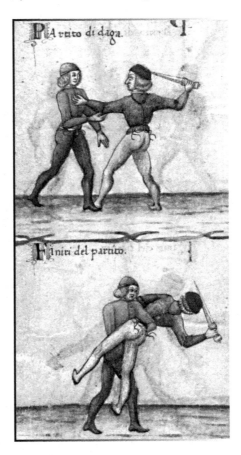

Folio 41V

Having grabbed his right wrist with your left hand, presumably as a defence against his low attack, instead of stabbing him with the dagger in your right hand you shoot your right arm between his legs and lift him off the ground to throw. Why you would go to such efforts, instead of simply stabbing him, is not explained.

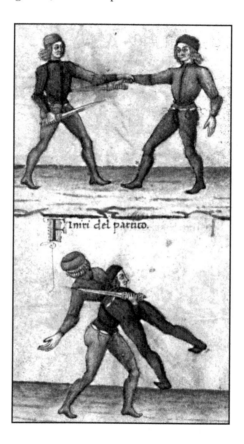

Folio 42R

Defence against a grab from behind: both of you holding daggers. Turn to your right, reach behind and through his legs and throw him. Again, why you would not use the weapon in your hand is unclear.

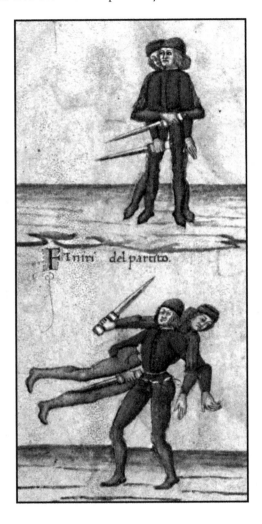

Folio 42V

Both of you have grabbed each other's jackets, your dagger is high and held back, he is stabbing from below. Shift your left hand from his jacket to his right wrist, and strike over his left arm into his chest. I think the lesson here is to control the weapon. As Fiore points out in the fifth master of the dagger, the grab to the jacket gives an advantage to the person being grabbed, not the one doing the grabbing.

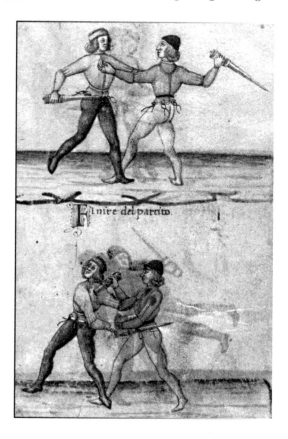

AFTERWORD

THIS IS A book I never intended to write; it just sort of happened. It is telling that from initial idea to first printing took almost exactly one year – I got the feeling early on that this work was the necessary next step in my exploration of medieval Italian swordsmanship. I was hugely encouraged by the support of the patrons; I had no idea that so many people were willing to support this kind of work, and so generously. There is certainly no commercial market for books like this, that occupy a niche within a subset of a minority, but the subscription model of publication worked exceptionally well.

Reading this book, with its many references to Fiore's plays, it may appear that Vadi's work is simply derivative and of little value, but this could not be further from the truth. While it is impractical to base an entire syllabus on this little book, and while Vadi adds nothing of note to our understanding of the use of the spear, sword in armour, pollax or dagger in this period, his contribution to the theory and practice of the longsword out of armour is simply invaluable. Most especially, his treatment of the meza spada crossing fills a void which practitioners of Italian swordsmanship have previously only been able to fill by reference to German sources. There is a wealth of information in his introductory chapters that has changed the way I handle the sword, shone light on some of Fiore's trickier plays, and perhaps most importantly, taught us how to feint at the half-sword.

There is much work to be done, of course. I intend to have every play videoed and online within a year of this book being printed. There is no substitute for working through the plays sword in hand, filming the results with the merciless camera, then going back and fixing it, again and again. I confidently expect many of the assertions and interpretations I've made here to change during this process, and the ebook version will probably be updated at some point.

Nonetheless, I trust that this work will be of value to Fiore scholars, longsword enthusiasts, and medievalists of every stripe.

Guy Windsor
Helsinki, November 2012.

List of Patrons

I WAS DEEPLY touched by the enthusiastic support of those kind souls who chose to patronise this little book. Many chose to remain anonymous, those who did not are:

Christian Cameron	Joonas Iivonen
Neal Stephenson	Maxim Zakurdaev
Hannu Lukkarinen	Craig Johnson
Royce Calverley	Timo Sainio
Yancy Orchard	Tuomo Rissanen
Laura Kostur	Keith Alderson
Jennifer Landels	Jason Smith
Wolfgang Pretl	William Beard
Aljaz Kosmerlj	Mike Prendergast
Christoph Gersmann	Richard Marsden
Ilpo Luhtala	Dan Sellars
Cooper Braun-Enos	Markku Rontu
Markku Rontu	Adelheid Lawler
Robert Sulentic	Brandon Uttech
Roger Windsor	Topi Mikkola
Niklas Brending	Robert Gallasch

Christopher Halpin

Jean-Remy Gallapont

Simon Halpin

Scott Aldinger

Kliment Yanev

Tomas Suazo

James Steiner

William Ernoehazy

Taneli Pirinen

Tomi Korkalainen

Cazimir Bzdyra

Anders malmsten

Jim Diver

Mark Oswald

Jean-Francois Gagné

Devon Boorman

Michael Stokes

Ville Vuorela

Merja Polvinen

Brian Stewart

Otto Kopra

Bungalow Publishing

Konstantin Tsvetkov

Zoe Chandler

Tracy Mellow

Dan Sellars

Mathieu de Chalain

Tuomo Rissanen

Timo Sainio

Cameron Davidson

Eric Artzt

Holly Hunt

Marko Saari

Lenard Voelker

Tim Owens

Andrew Somlyo

In addition I would like to acknowledge the excellent editorial work done by Richard Marsden, author of the Traveling Tyrant novels, and the artful layout and book design by Bek Pickard of Zebedee Design.

Thank you all!

BIBLIOGRAPHY

PRIMARY SOURCES:

Fior di Battaglia (MS Ludwig XV13), J. P. Getty museum in Los Angeles.

Fiore de' Liberi's Fior di Battaglia translation into English by Tom Leoni, 2009

Flos Duellatorum, in private hands in Italy, but published in facsimile in 1902 by Francesco Novati.

Fior di Battaglia Morgan MS M 383, Pierpont Morgan museum, New York

Florius de Arte Luctandi (MSS LATIN 11269), Bibliotheque Nationale Francaise in Paris

De Arte Gladiatoria Dimicandi, Filippo Vadi, Biblioteca Nazionale di Roma

De Arte Gladiatoria Dimicandi, Filippo Vadi, translated by Luca Porzio and Gregory Mele, 2002

Gran Simulacro del arte e del uso della scherma, Ridolfo Capoferro, 1610

SECONDARY SOURCES:

Dizionario di Abbreviature Latini ed Italiani. A. Cappelli, Milan1912. Available online at: http://www.hist.msu.ru/Departments/Medieval/Cappelli/

WordReference: online Italian-English Dictionary: http://www.wordreference.com

Vocabolario della Crusca, (1612) available online at: http://vocabolario.signum.sns.it/_s_index2.html

Latin translation tool: http://www.perseus.tufts.edu/hopper/

Lightning Source UK Ltd.
Milton Keynes UK
UKOW04f0618181217
314677UK00001B/111/P